The Cotswolds

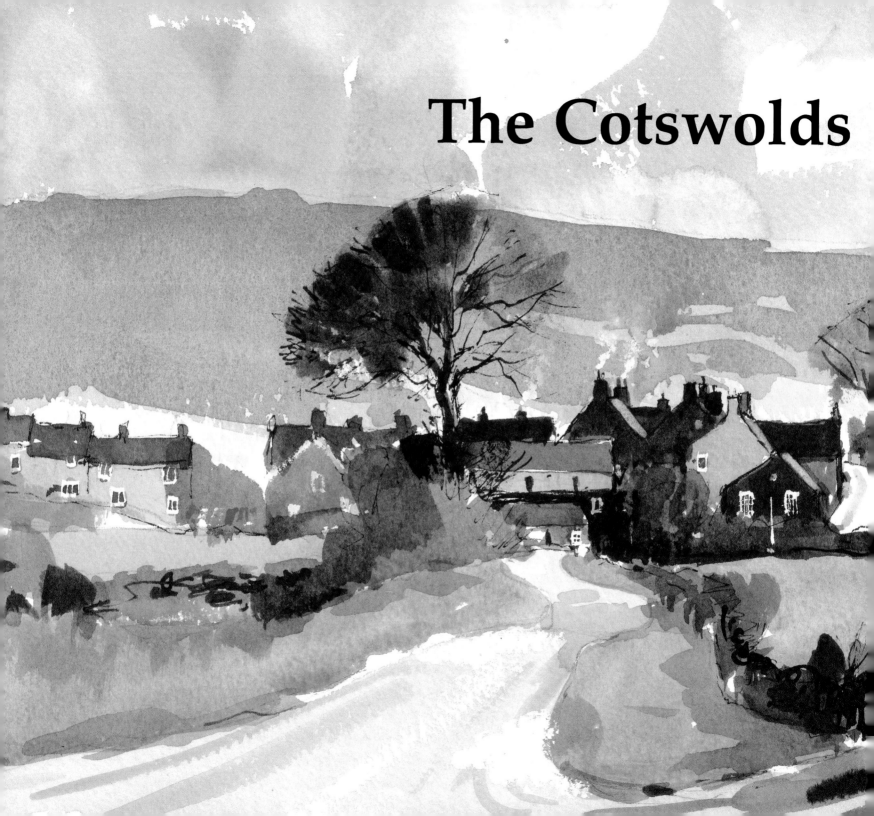

The Cotswolds

Watercolours by John Tookey Words by Christopher Hall

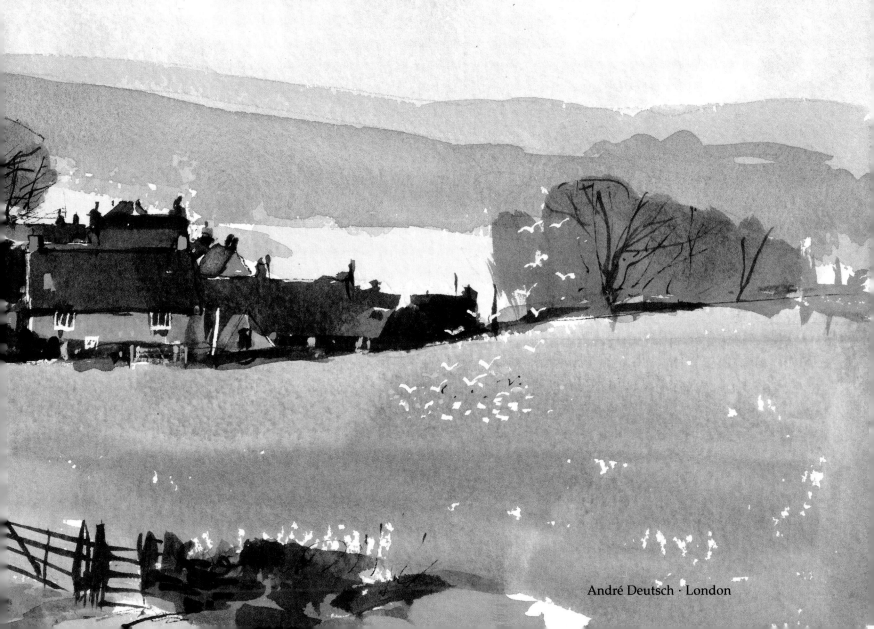

André Deutsch · London

First published in Great Britain in 1990
by André Deutsch Limited
105–106 Great Russell Street London WC1

Maps drawn by Hanni Bailey
Designed by Peter Guy

ISBN 0 233 98554 9

Typeset by CentraCet, Cambridge
Printed in Hong Kong

Contents

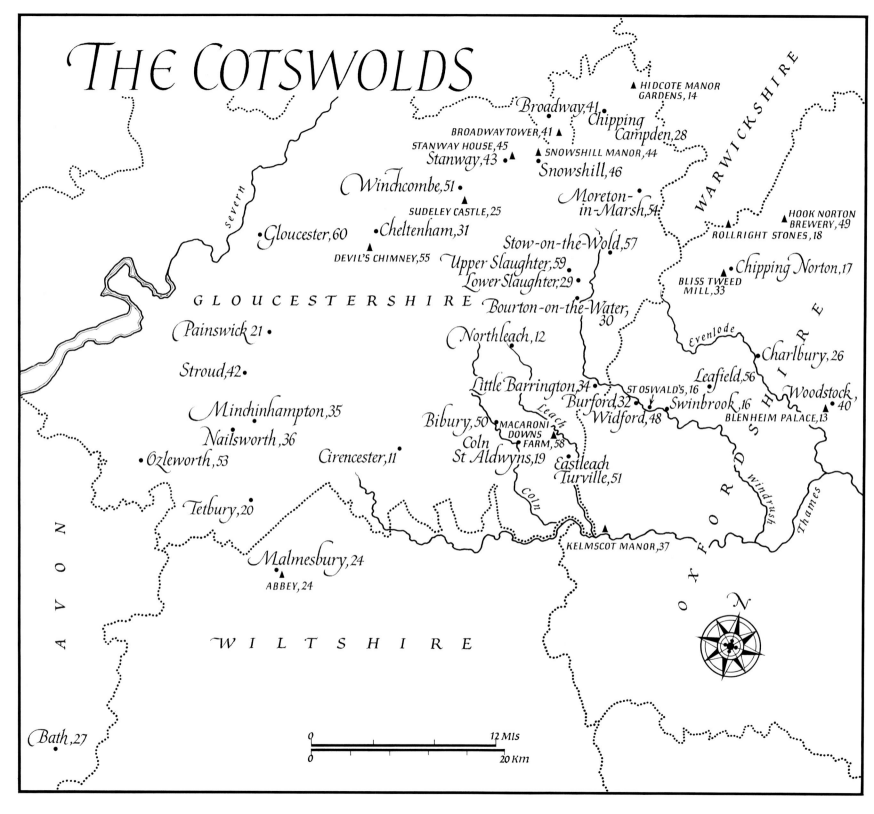

THE COTSWOLDS

WARWICKSHIRE

▲ HIDCOTE MANOR
GARDENS, 14

Broadway, 41

BROADWAY TOWER, 41 ▲ Chipping
 Campden, 28
STANWAY HOUSE, 45 ▲ SNOWSHILL MANOR, 44
Stanway, 43 ▲
 Snowshill, 46

Winchcombe, 51 Moreton-
 in-Marsh, 54

SUDELEY CASTLE, 25 ▲ ▲ HOOK NORTON
 BREWERY, 49
Gloucester, 60 Cheltenham, 31 ▲ ROLLRIGHT STONES, 18
 Stow-on-the-Wold, 57
 DEVIL'S CHIMNEY, 55 ▲ Chipping Norton, 17
 Upper Slaughter, 59
 Lower Slaughter, 29 BLISS TWEED
 MILL, 33
GLOUCESTERSHIRE Bourton-on-the-Water,
 30 Evenlode

Painswick 21 Charlbury, 26
 Northleach, 12
 Leafield, 56
Stroud, 42 Woodstock,
 Little Barrington, 34 ST OSWALD'S, 16 40
 Burford 32 Swinbrook, 16
Minchinhampton, 35 Bibury, 50 Widford, 48 BLENHEIM PALACE, 13
 MACARONI
Nailsworth, 36 DOWNS
 FARM, 58
Ozleworth, 53 Cirencester, 11 Coln
 St Aldwyns, 19 Eastleach
 Turville, 51

Tetbury, 20

Malmesbury, 24 KELMSCOT MANOR, 37 ▲

ABBEY, 24

WILTSHIRE

N

Bath, 27

0 12 Mls
0 20 Km

AVON

severn

Leach

Coln

Windrush

Thames

OXFORDSHIRE

Introduction

The first time I looked down The Hill I caught my breath.

Let me explain. The Hill is what we who live in Burford, on the Oxfordshire slope of the Cotswolds, call the top part of our little town's main street. Halfway down it is metamorphosed into the High Street, but it is all one long, lovely street sloping down from the low ridge, along which the Oxford-Cheltenham road has run since 1812, to the ancient bridge over the Windrush at the bottom nearly half a mile all told.

But I didn't call it The Hill then. This was more than forty years ago and Burford was the very first Cotswold place I had encountered. I lived on the rural fringe of London and was taking a walking (hitch-hiking might be more truthful) holiday from youth hostel to youth hostel. The Cotswolds for me were still part of the vast mass of *terra incognita* which made up the map of Britain – a jigsaw of coloured counties which were gradually coming to life through inspection and the one-inch-to-the-mile 'New Popular Edition' of the Ordnance Survey at three shillings per cloth-backed sheet.

I had spent the previous night at Oxford. So Burford was for me exactly what it claims to be: 'the gateway to the Cotswolds'. There are several other places that make the same claim, but then there may be a number of gates. And The Hill took my breath.

At the time I didn't stop to try to analyse why. One of the pleasures of doing this book, along with seeing how well John Tookey has caught the spirit of the area, has been to work out for myself why The Hill then and the Cotswolds now have the power to charm me and to charm many tens of thousands of others.

As to the Hill itself, there are three things. First there is the long, wide gracious sweep of it. Catch it at five-thirty on a Friday evening when it is gridlocked solid by traffic and it may be hard to appreciate, but at almost any other time it is possible to dismiss the distraction of moving and parked vehicles sufficiently to grasp what you are looking at. Best of all, look down at the end of a summer evening or very early in the morning; few cars and better light.

Second, there is the variety of buildings. They come in contrasting shapes and sizes, although nearly all are in the same stone. The Bull Hotel is of brick and when it was almost burned down a few years ago we loyally insisted that it be rebuilt as

before – the only building built entirely in brick. As for the others, some stick out, some shrink in. The windows of some bulge while others are flush with their neighbours. Two-thirds of the way down on the right is an extraordinary classical building which is in fact the Methodist church, set back a little. The gently sloping bottom end is satisfactorily closed off by the old vicarage with Dutch gables. The 'model old English town: the all-England model' as John Piper said.

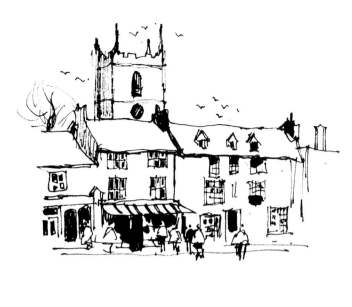

And third, there is the view beyond. There were elms in that view of the fields rising on the far side of the Windrush when I first looked at it. I can't say I specially noticed them (we didn't, did we?), I know from photographs that they were there. But it is still a lovely view and a lovely backcloth to the town.

Before I go any further, I had better finish my say on traffic and what brings it to the Cotswolds, by stating quite clearly that the Cotswolds are over-visited and are undergoing social changes for the worse. Some villages sport a B & B sign on every other cottage. In others, pedestrians are dwarfed by great glossy, glassy coaches parked while the driver puffs his fag and waits for his flock to re-embark and vrroom off to the next stop.

And in all our villages and some of our towns it gets harder to find families who have been in the place for more than a couple of generations. Such is the impact of mobility and house prices. The Cotswolds have always been, to borrow from the limited vocabulary of estate agents, 'desirable', 'favoured' and 'sought-after' for living in. Never more so than now. The influx of new people means that we have immaculate villages. It also means that we have mock-Georgian doors with grotesque fanlights inserted into our seemly cottage-fronts and windows let into our slated roofs, often when the planners, whom we must regard as generally benevolent, are powerless or looking the other way. And outside the villages it means that our comfortable old barns are the object of tasteless conversion at a rate which is fast qualifying as a major blight.

But when all is said, the Cotswolds are still capable of making me catch my breath and in this book John Tookey and I have tried to show you why.

At the heart of the matter is the stone, which is very hard to obliterate. The pull of the Cotswolds is essentially in the towns and villages. There is good countryside – a fine escarpment with sweeping vistas, the deep valleys and woods of the southern hills and the fine bleaknesses of the wolds that once carried nothing but

sheep. But it is the domestic cosiness of the small settlements which makes the tourists gasp with delight, as they look out through the tinted glass of their coaches or park the rented car outside another Cotswold hostelry, and that cosiness comes from the stone.

The Cotswolds are made of limestone, oolite to be precise. It is lovely to look at and good to work with. It exists in abundance and, until quite recently, it was a lot cheaper to hack out the limestone locally than to import other materials. In fact we used to export it. There are Cotswold buildings all over: St Paul's, made from the product of Kitt's Quarry, half a mile outside Burford, is one; Oxford colleges include many more.

This oolite has two great virtues in building. Texture and colour.

It is a good stone to work with. That is why quite modest and humble little buildings in the Cotswolds display sizeable blocks of smoothly-faced and cleanly-edged masonry. That is why such buildings enjoy a level of fanciful and imaginative decoration that would surprise you elsewhere. My own house has three (probably) Tudor gables at the back. Each of them is topped off with a little ball of limestone. In recent years one of these had come adrift and smashed on the terrace. I confess that I hardly noticed. But when we had the roof repaired a few years ago, carefully replacing those of the Stonesfield slates which were past further service with more of the same, the men from the local builder's quietly made a new finial ball, without being asked to. Cotswold cottages carry dates and the initials of builders or first owners more commonly than those elsewhere; and that is because to add these touches on the oolite is not difficult. The stone invites individual attention and craftsmanship.

The colour of the stone has exhausted the most willing muses of those who have written about the Cotswolds. The available adjectives have been worked to the bone: golden, grey-gold, tawny, honey-coloured – you will find some of them no doubt in the pages that follow. But the point is that there is no correct adjective for Cotswold stone. There were many quarries and their products were all different. Guiting was traditionally said to produce the *golden* stone. Taynton was a good deal more *grey* and so on. And because this stone is quite malleable when newly dug, but hardens up quite quickly, it changes or develops colour according to its position. Stone from the same quarry will look different in different places, according to the weather to which it

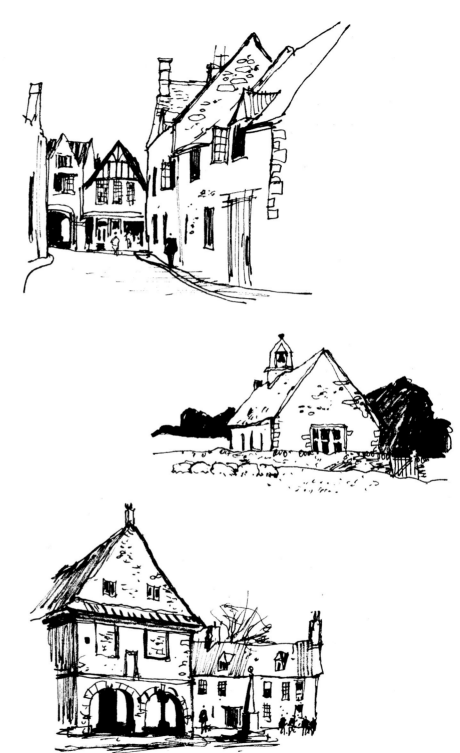

has been exposed or the light or shade of its site.

If you are an observant sort of person you will notice, when you first go to the Cotswolds, that the towns and villages do differ subtly from each other even though the building material is essentially the same. When you know the Cotswolds well, you will notice that equally subtle, but just as important, differences distinguish one building from its neighbour in the same street.

So how will you get to see these still entrancing Cotswold places? You can whizz round in your car or even tour gently in the same. There are some buses. There are trains too to a few parts of the area. A surprising lot of people, given the steepness of the hills, use bicycles. But I suggest you walk whenever and wherever you are.

That old Ordnance Survey map which I mentioned at the start was a sturdier job than anything produced now. But it had one great drawback. It bore the grim caveat: 'The representation on this map of a Road, Track or Footpath, is no evidence of a right of way.' But the Pathfinder and Landranger OS maps of today do mark the public footpaths and bridle-ways in which the Cotswolds are rich. Of course these paths are subject – as elsewhere – to the too-frequent hostility, greed and neglect of contemporary agriculture, but in general you should not have much difficulty if you read your map carefully. These days even farmers who have planted barley across a path are well aware of the public's rights. And they may have at the back of their minds that the missus is doing bed and breakfasts now and would rather not be rude to potential customers.

And, since the buildings are so important, take not only the Ordnance Survey map, but the appropriate county volume of the Buildings of England series as well, edited originally by Nicolaus Pevsner. These are miracles of condensed information and easily portable.

So walk if you can. You will see more and you will see it more thoroughly. And most important you will come at our towns and villages by surprising, forgotten ways, slipping across the field to the wicket gate into the churchyard or up from the river bank by the mill to the village street. And then you too may catch your breath in wonder.

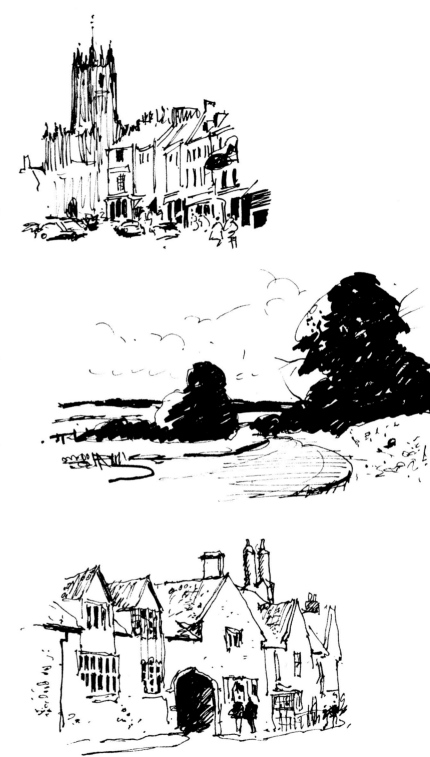

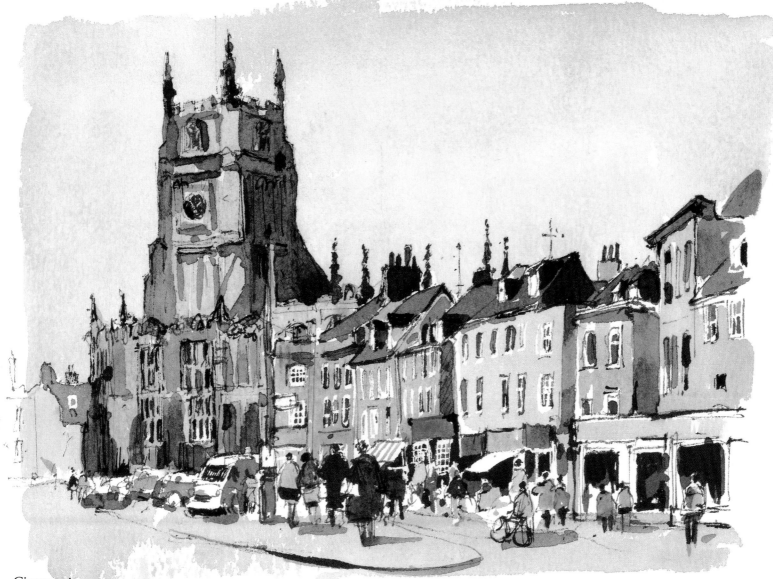

Cirencester

If the Cotswolds became an independent state, Cirencester would be its capital since it is the biggest town (leaving aside Cheltenham and Gloucester which lie outside the hills proper); and the state's kings would be anointed or its presidents sworn in (as the case might be) in the great church which towers over its market-place.

This church is magnificent and ornate. Its stone is honey-coloured and serene above the clamour of the market. It is of course the largest parish church in the Cotswolds or in Gloucester-shire for that matter; it is bigger than some cathedrals. The richly panelled and enormous south porch juts into the market-place, perfectly marrying the ecclesiastical with the secular and commer-cial power. Inside, the church's plate is as rich and fascinating as befits a great wool-town whose merchants for centuries poured wealth into the church.

Cirencester boasts one of the best small museums in Britain, the Corinium, devoted to the Roman past of the town and its region. It is erudite without being dull and informative without being patron-ising. This was in area the biggest town of Roman Britain. It stood imperially at the intersection of three great roads – the Foss Way, Akeman Street and Ermine Street, whose still traceable lines we meet again and again throughout the Cotswolds and beyond.

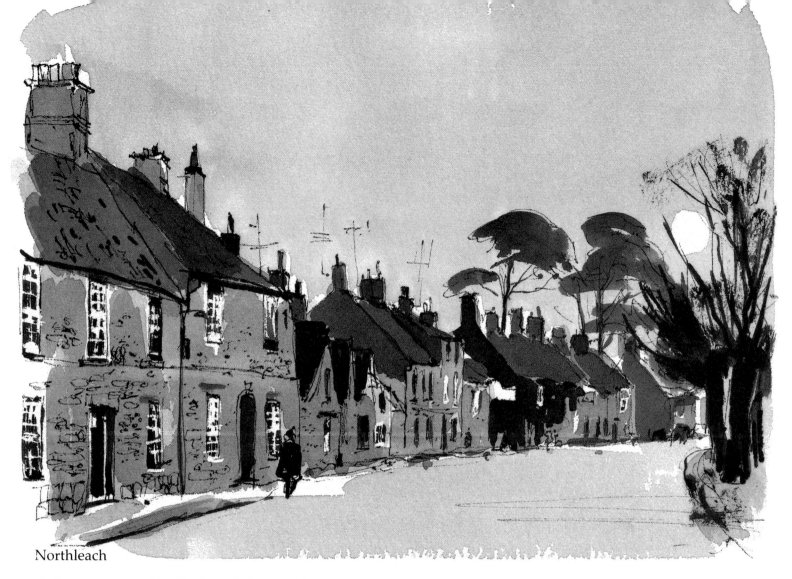

Northleach

Until a year or so ago Northleach was hell on earth because the main London-Oxford-Cheltenham road, the A40, was its main street. Now a by-pass slices crudely across the field pattern and ancient green lanes north of the town. Hell has at least been shifted. Towns like this – Burford is a current case – pray for just such deliverance and there is much jockeying for position in the programmes of the county councils' highways departments. Yet not everyone is satisfied. When Northleach was at last relieved, the good citizens felt it necessary to advertise the presence of their ancient town and its charms on the very by-pass they had campaigned for. In Burford the traders of the High Street don't want a by-pass lest it take away their passing trade.

Anyway, Northleach has two great attractions besides its inher-ent architectural charm and relative peace. One is a mighty church built with wool money; it rates as great as those at Cirencester and Chipping Campden, in one way perhaps greater because North-leach is a smaller place than either of those so the church's massive tower is more dominant. But last time I called the doors were locked and there was nothing to tell me where I might find a key. I count that an unfriendly act in a place that seeks visitors. The second is at the western end of the town where in 1790 Sir Onesiphorus Paul built a model 'house of correction' in which prisoners were given proper places to sleep and rudimentary sanitation – well ahead of its time. This is now a museum of farm implements and vehicles. That should fetch 'em off the by-pass.

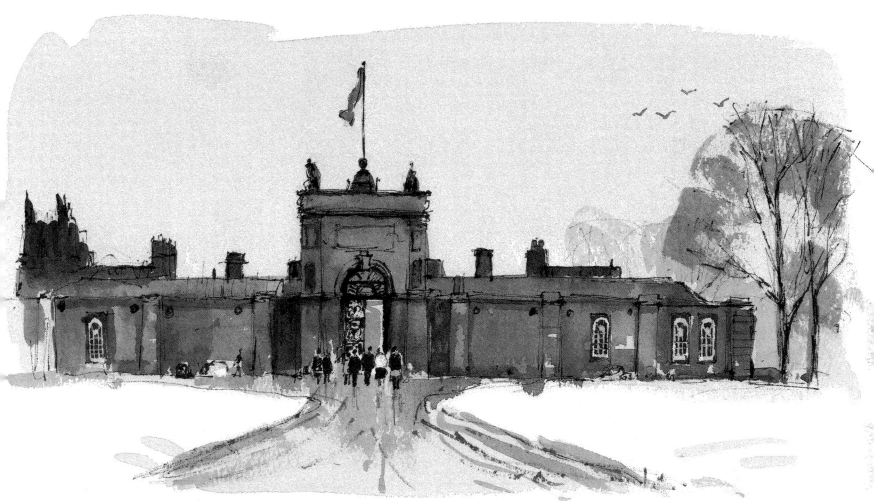

Blenheim Palace

This is one of the great magnets for seekers of stately homes. Its magnificence awes the semi-detached late twentieth-century gawper, the more so because this remains a private home, albeit a very public one. Yet we are looking at the outcome of a series of accidents. The first Duke of Marlborough might have lost his battle against the French and Bavarians at Blenheim, an obscure settlement on the Danube. In that case Louis XIV's imperial ambitions would not have been checked and a grateful Queen Anne would not have given the Duke the money to build the palace. Wren might have got the job instead of the relatively inexperienced dramatist, John Vanburgh. And the Duchess of Marlborough who wanted only 'a clean sweet house and garden be it ever so small' might have got her way.

Nobody could call Blenheim sweet: grand, swaggering, braggart are the words that come to mind. But there it is. It isn't my taste and I'm not going to take you round, but I don't mind exploring

the park. We are still in the Cotswolds (the palace was built of Taynton stone from quarries near Burford). The great lake in the park is fed by the Glyme, a tiny stream which flows down from the vicinity of Chipping Norton to join the Evenlode at Bladon in whose churchyard another great victor, Winston Churchill, is buried. Vanburgh made the 'state approach' to the palace by building his Grand Bridge over the Glyme. The Duchess disliked it and neglected it. It must indeed have looked ridiculous, until Capability Brown saw the potential, damned the stream and so created the two long lakes which complement the bridge.

Over the bridge bear right and go up the long strip of parkland past the Column of Victory. After about a mile a public path on the left enables you to make a circuit via Park Farm and the magnificent oakwood by High Lodge and thus back to the lower lake and the palace. This is the bucolic rather than the state approach. A good ramble and I'm glad we won at Blenheim.

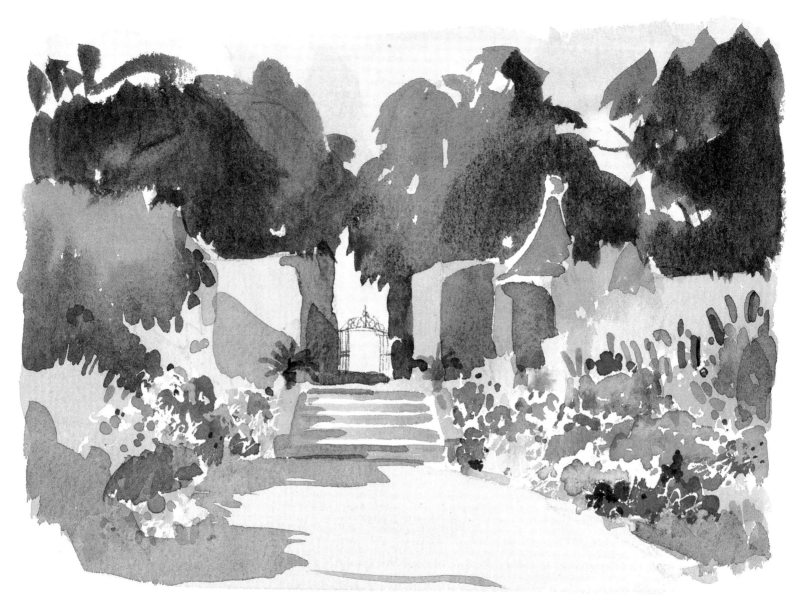

Hidcote Manor Gardens

This is a place which *afficionados* of the modern (post-Gertrude Jekyll) garden rave about. It is rightly named in the plural, for there are many gardens here separating and merging kaleidoscopically. The whole was started in 1905 by an American, Major Lawrence Johnston. It extends over eleven acres on the acid soil of the high Cotswolds, four miles north-east of Chipping Campden. My impression of the place (and I am no gardener) is more of a stage set than anything else. It seems to be laid out for a series of dramatic interactions. The arches made from hedges invite sudden entrances and exits, surprises and embarrassments. There are trees to hide behind and occasional longer vistas down which one expects to see an intriguing couple locked in talk. It is very much the sort of garden in which an Iris Murdoch novel ought to be set (and probably has been).

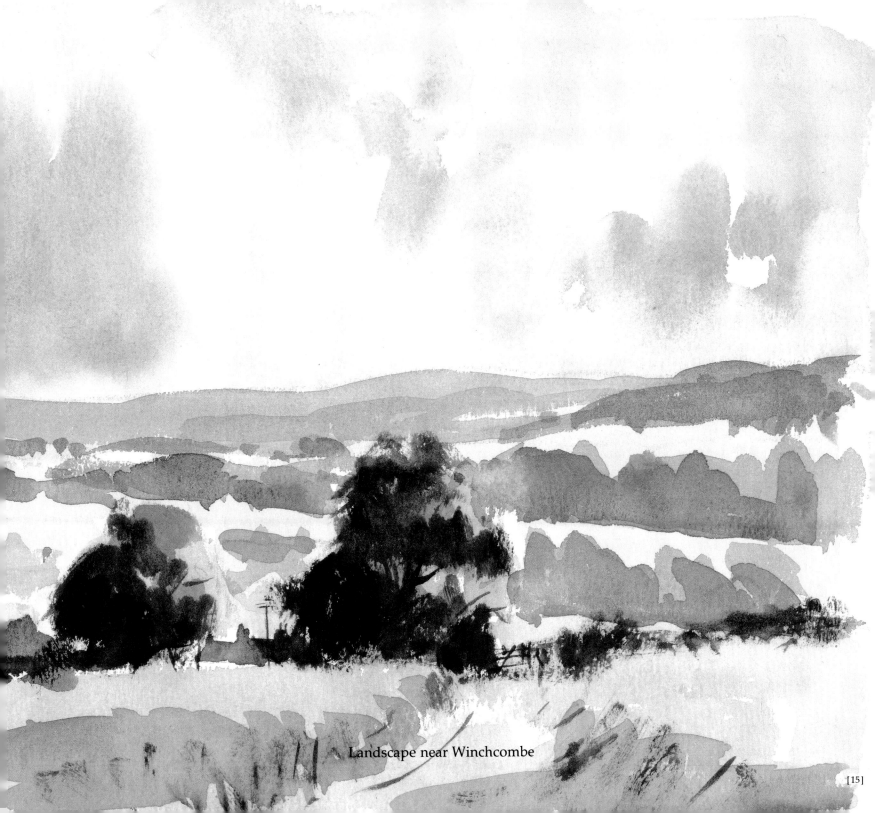

Landscape near Winchcombe

Swinbrook,
the Fettiplace Monuments

The Fettiplaces were a power in the land for centuries. But the last of them died in the year of Trafalgar. Their mighty house, which stood south of the church, has left no trace. But their name will be remembered as long as their monuments continue to fill the west wall of the chancel of Swinbrook church.

These are remarkable effigies, laid as it were on shelves, stone sleepers in the couchettes of an eternal *wagon-lit*. The monuments repay a little study. They are not all in the same style. The earlier ones are armoured and stiff; the later ones softer in their alabaster and marble.

And we are not yet finished with death. When you have sufficiently pondered the transience of the Fettiplaces, go out into the churchyard overlooking the fields of the Windrush valley. Here you will find associations with another local family now gone from the place. Two daughters of the second Lord Redesdale's remarkable clutch are buried here: Unity Valkyrie Mitford, who had a thing about Hitler, and Nancy Mitford, the writer. The family lived in the big house in the next village.

From here it is ten minutes' pleasant stroll across the fields by a clear path to Widford church (see p. 48) and thence across the meadows to Burford. All along the line of hill facing the church runs the never-ceasing traffic of the A40. I hope the Fettiplaces savour their peace.

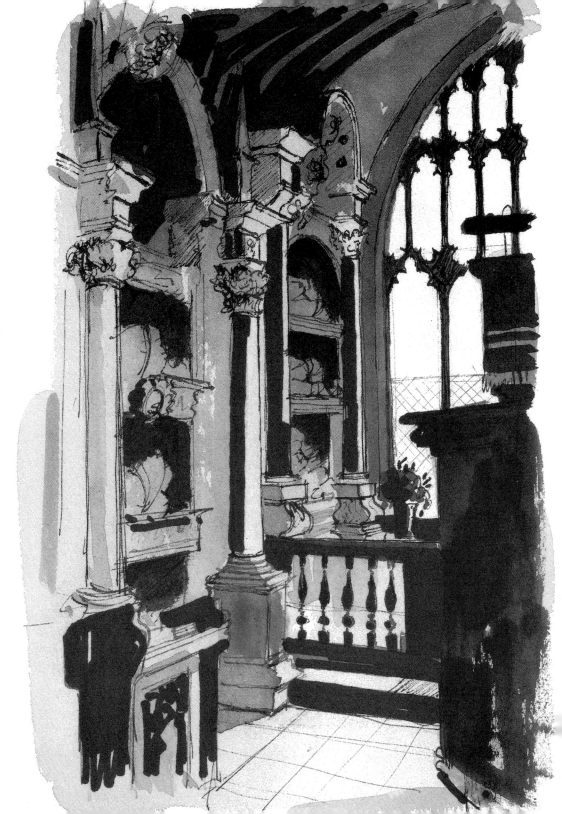

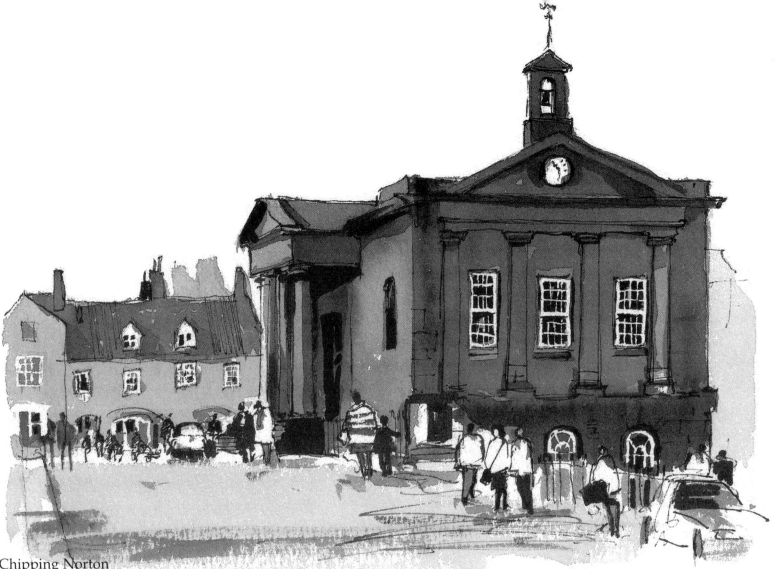

Chipping Norton

Chipping Campden, nine miles away, is never called 'Chippy'. Chipping Norton is rarely called anything else by local people. Why? Perhaps because, of all the Cotswold towns with any claim to good looks, this most nearly remains a working community. Maybe the isolation has something to do with it; for not only is this the highest town in Oxfordshire, it is stuck out on a limb, close to the Gloucestershire border and half a mile off the main Oxford-Stratford road. To add to its oddness, it regularly elects a Labour county councillor (I report this fact for its curiosity value only, such things being unusual in West Oxfordshire).

There are a busy central market-place and main street. Perhaps because of the configuration of the roads and a well-placed double roundabout, vehicles here do not overwhelm as in so many other old and unbypassed towns. And in the middle is this remarkable building, set oddly askew to the Market Place, presiding over everybody's comings and goings. It is in fact the town hall, dating from 1842 and complete with Tuscan portico.

As to the rest of the town, it is the sort of place of which the Pevsner guide says: '. . . has few secular buildings of architectural interest and does not merit a detailed per-ambulation'. Poor old Chippy, so you had better perambulate to the non-secular and inspect the church which is something of a mishmash (as a proper English church should be), but does – Pevsner again – possess 'one of the finest fifteenth-century interiors in the county outside Oxford', which, when you think of all that covers, is praise indeed.

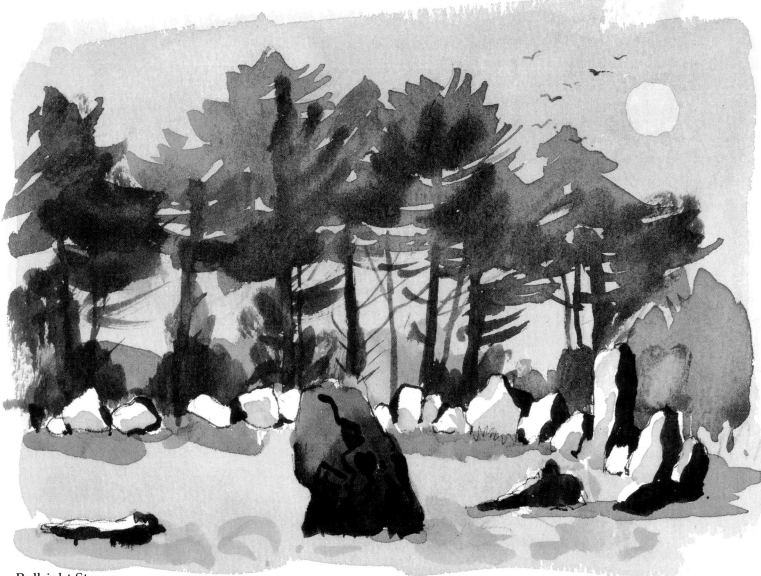

Rollright Stones

No moon is needed to enhance the numen of these stones. Age-gnarled, their sentry conifers lending a slightly Teutonic touch, the Rollright Stones have always been a mystery. The archaeologists have them more or less slotted – Bronze Age, not that it tells us much since that could be any time from 2100 to 700 BC. And some books say Late Neolithic which widens the field still further. But it is their folklore which clusters most thickly.

Peaceful, though within earshot of the busy Oxford-Stratford road, the main circle is the King's Men – some 70 stones and some 30 yards in diameter. Within the circle was a long barrow and the arrangement is supposed to have been ceremonial. The folk-tale is that a king and his army were petrified eternally by a local witch. The King's Men are the army. The king became the King Stone which lies just across the road from the circle and thus in Warwick-shire not Oxfordshire. His knights became the Whispering Knights: four stones (the walls of a burial chamber it is supposed) about half a mile from the circle itself.

The stones stand on a narrow watershed. Northward the streams flow to the Stour and so by Avon to the Severn and the Atlantic; south to Evenlode, Thames and the North Sea. The Cotswolds, low and gentle hills, are one of the divides of Britain.

Coln St Aldwyns

To judge from the state of things around the green and the bridge on a fine Sunday, most people come to Coln St Aldwyns by car, but nature's way is best. Walk along the River Coln from Bibury a mile or two to the north-west. The paths are well trodden and a clearly signed bridle-way leads by the river. There is an alternative route back on the other side of the Coln.

A splendid conker-strewing horse chestnut dominates the green. There is a fair bit of Norman work in the church, but its claim to glory is that John Keble, initiator of the Oxford Movement, was curate here (1825–35) in the last decade of his father's reign as vicar. The local grandee, Sir Michael Hick-Beach (later Earl St Aldwyn) did over the Manor House, more comprehensively than wisely they say, while he was Chancellor of the Exchequer in the 1890s.

Tetbury

This has always been a prosperous place and the present age is no exception. Drive into it and, unless you are careful, you will find yourself emerging inexorably on the other side before you have stopped. Needs a by-pass, but then where doesn't? At the moment the 1655 Market Hall is not much more than the island in a roundabout. And while we're noticing the drawbacks, what happened to the hotel known for centuries as the White Hart? – now called the Snooty Fox.

Start with St Mary's church, an excellent building of eighteenth-century Gothic. And don't miss the famous tablet whose inscription runs:

> In a vault underneath
> Lie several Saunderses,
> late of this parish: particulars
> the Last Day will disclose.

There is a scatter of good buildings and the Market Hall is one of the best of its kind, although somewhat mucked about with. As the painting shows, they must have been drafty places to do business in.

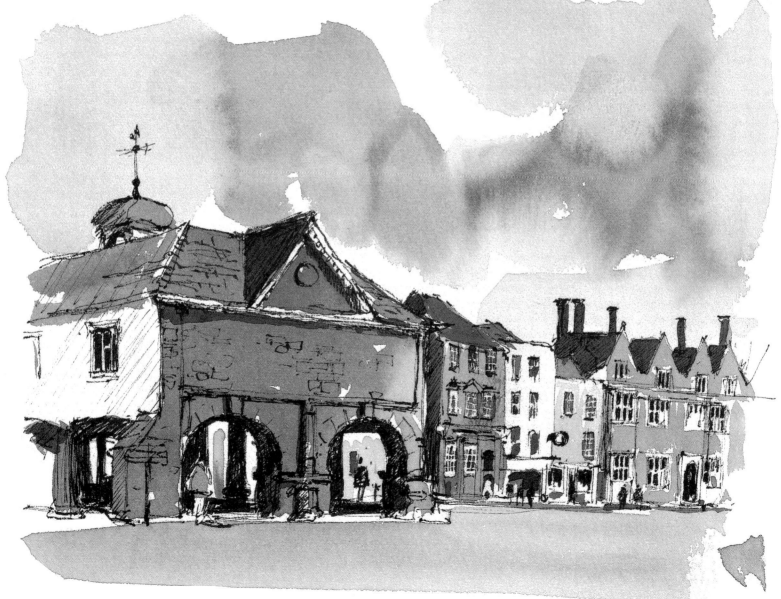

Painswick

I can never get out of my head the rhyme by James Elroy Flecker:

> Have I not sat on Painswick Hill
> With a nymph upon my knees;
> And she as rosy as the dawn
> And naked as the breeze?

I suppose he meant Painswick Beacon above the little town – a chilly place at 922 feet above sea level for such goings-on and to climb it you must brave low-flying golf-balls. Perhaps it is by association with the rhyme that I always think of Painswick as a jolly spot. I like to remember that Anne Boleyn was here with her Harry, while they were still in love, for what we would call a weekend break, not that she faced the axe within a year.

The church is good but probably more famous for its manicured yews (are there really ninety-nine of them?) than for the building itself. At one end of the churchyard are iron stocks for the disciplining of villains and it is notable that they date from 1840, so recently were these humiliations practised. Outside, the streets are not so self-conscious as in many Cotswold towns. Court House (1604) is an extremely good example of a Cotswold clothier's home, gabled and H-shaped. For something quite different look at Dover House (1720) which is early Georgian. And from 160 years later there is the William Morris & Co. window in the Congregational Church.

Outside the town is Painswick House, a fine Palladian mansion. You can see it only by appointment, but it is worth obtaining one. Access is not easy either at Prinknash Abbey which is a modern monastic house with only limited visiting by way of guided tours; but the famous pottery and its shop are open.

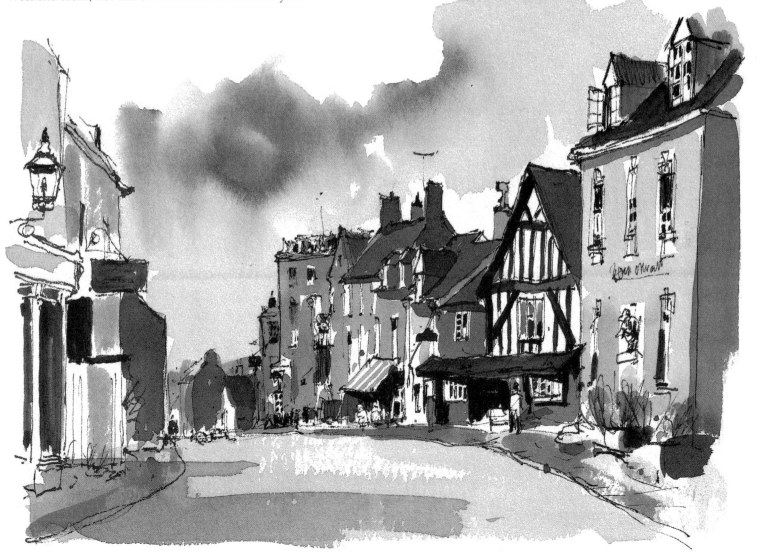

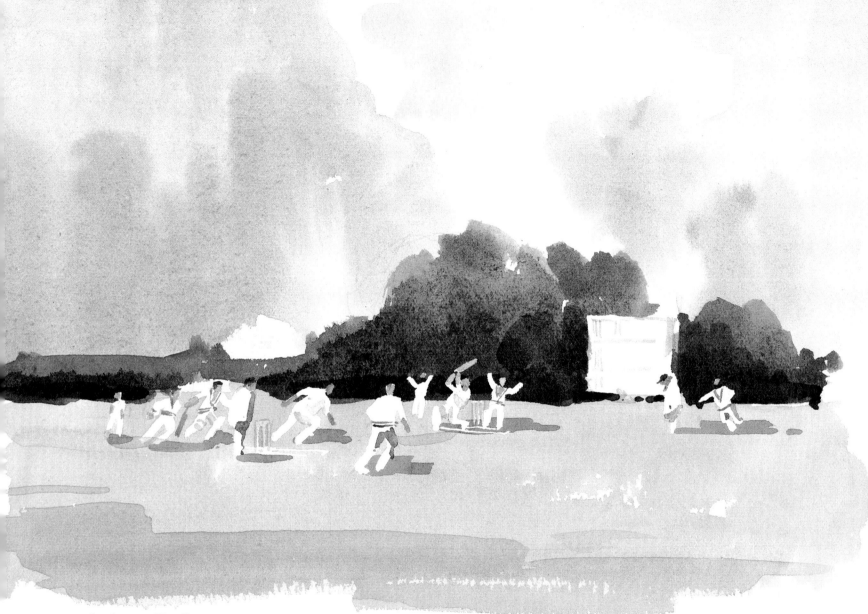

Cricket at Charlbury

The square-leg umpire, if his attention wanders, can look up to the dense, dark trees of Wychwood flowing over the hill beyond the railway. The ground is adroitly set in a meander of the River Evenlode below the town. The railway follows the river, a splendidly surviving steel thread linking the cathedral cities – Oxford, Worcester and Hereford – not to forget Edward Thomas's Adlestrop ten miles up the valley where express trains do not draw up even unwontedly nowadays. British Rail marketing insists on calling this route 'The Cotswold Line', which is fair enough for the inhabitants of Charlbury, because it is certainly a gateway to the hills. But it makes less sense in the Malverns or the cider-orchard country beyond. Never mind, the inattentive cricketer may reflect, there is Charlbury Station, the last survivor of the originals built for the Oxford, Worcester & Wolverhampton Railway (the Old Worse & Worse), an Italianate box preserved as a listed building. On a weekday it is lapped by acres of shining commuters' cars, but when the cricket is in progress at a weekend it reverts to being a wayside stop between the river and the trees.

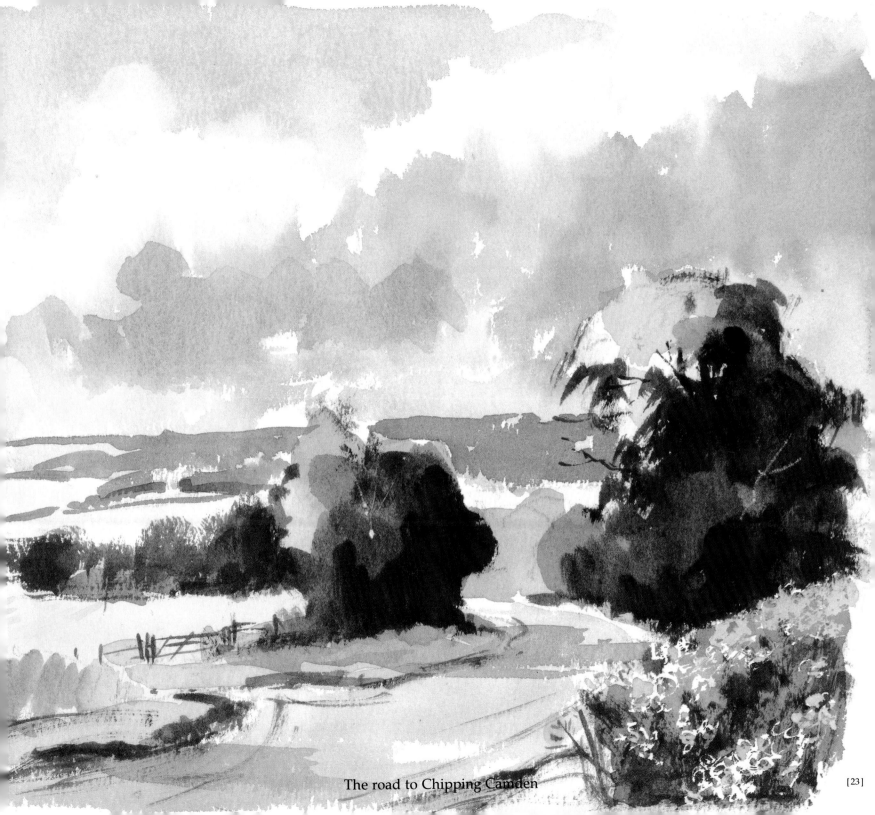

The road to Chipping Camden

Malmesbury

Let us remember William Stump. He was a prototype for future developers. When the Abbey at Malmesbury was sold at the Dissolution, Mr Stump, 'an exceeding riche clothier', bought it – cheap. He pulled some of it down, presumably with a view to some thrifty recycling of the stones; parts he turned into workshops. But his PR was good and, like modern developers, he knew that at least a gesture to the conservationist lobby was necessary, so he gave his permission for services to continue in the ruins, and that seems to have silenced any opposition.

Indeed Malmesbury does not seem to have given a damn over several centuries for the beautiful but stricken treasure. The parish had acquired the Abbey from Mr S., but let it continue downhill. No repairs were done, more stones fell off and the local builders knew where to come. In the early part of the last century an appeal for £10,000 was made to save what was left, but only half was raised. Another century passed before serious repair and maintenance began. So now enjoy it.

This town does not feel much like the Cotswolds. Indeed, having crossed into Wiltshire, we are not in one of the Cotswold counties at all. But Malmesbury has what Pevsner calls 'one of the finest' market crosses in England. It is octagonal, over 40 feet high, with battlements and flying buttresses. Pevsner asks its purpose and quotes Leyland: 'For poor folkes to stande dry when the rayne cummeth.' I suspect it was conspicuous commercialism to glorify the market-place, as a modern municipality will build a fountain with tropical greenery in its shopping precinct.

Sudeley Castle

That assured, moated air is phoney. This is a place in which to reflect on the mercurial, freebooting ways of the aristocracy. Here are just a few readily gleaned facts.

The castle was built by Ralph Boteler around 1398. After holding it by inheritance for seventy years, he was pushed out by Edward IV, whose brother had it for a few years, until it reverted to the crown, where it stayed until given to Lord Admiral Seymour in 1547. He became the fourth husband of Katherine Parr, widow of Henry VIII. Less than ten years later it passed to Sir John Brydges who became Lord Chandos. At least two other families have had it since then. Henry VIII dropped in with one or two of his wives and Katherine Parr is buried here. Queens Mary and Elizabeth spent time here and from here Lady Jane Grey set out to London and the block.

The castle is beautiful and beautifully set in parkland. Part of Ralph Boteler's building is still there – notably the outer court and gateway. More of his work is nearby, the church and the great barn. The castle has all the desirable amenities, including a dungeon tower, inner and outer courts and presence chamber. And you can take the kids because there is lots for them to do in the grounds.

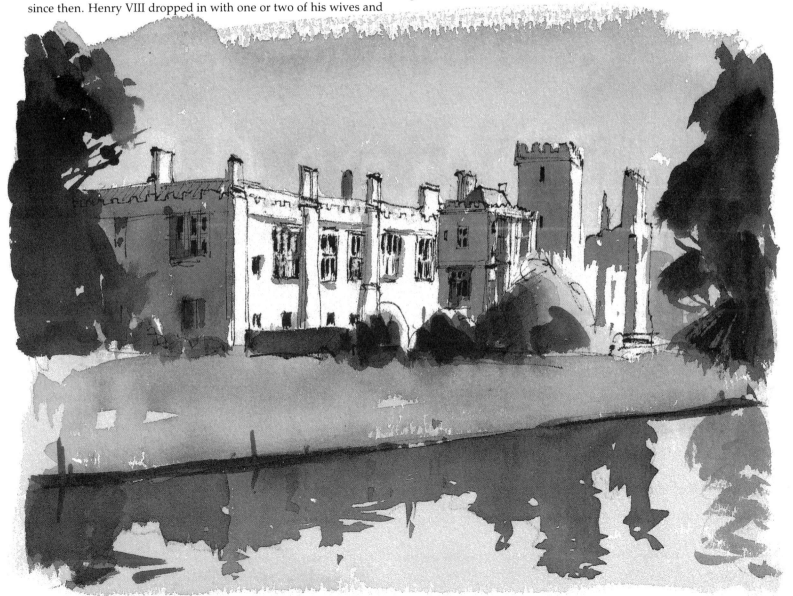

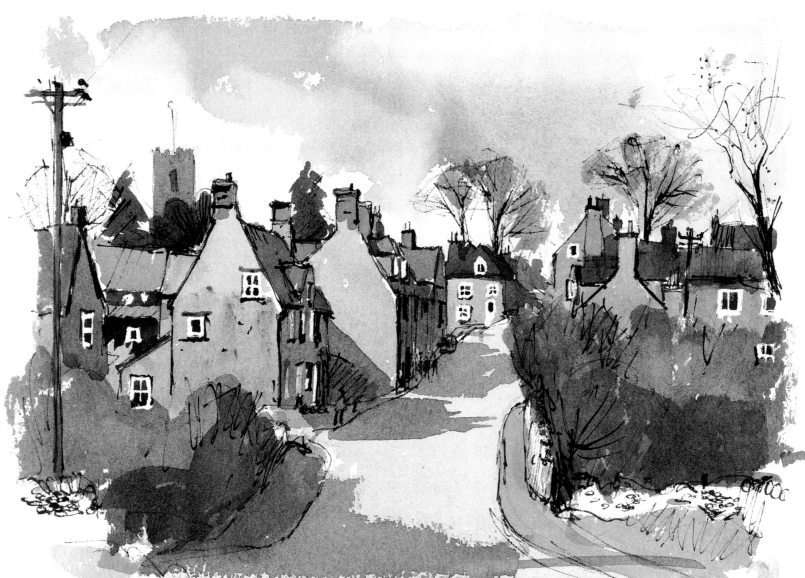

Charlbury

In Charlbury we are on the very edge of the Cotswolds and really part of the booming high-tech south-east. Oxford is only a few miles away and from the town's little station hundreds of commuters are whisked daily to Paddington in 125 expresses. So the town is on the cusp between its old identity and being a mere dormitory.

Physically it remains a country town. For centuries it was famous for glove-making. It has a slightly feudal air for it stands almost at the gates of Cornbury Park and the fastnesses of Wychwood behind. A long battle to win some access to the forest has just ended in victory for ramblers and the Oxfordshire County Council which made an order creating a new right of way. But the townspeople of Charlbury played little part and the town council formally opposed the path at public inquiry – nobody quite knows why.

For walkers along the Oxfordshire Way, which links the Cotswolds and the Chilterns, Charlbury is an important staging-post, possessing pubs, a youth hostel and a fish-and-chip shop to name only three amenities. Short-distance strollers can follow the way up the valley to the three villages whose names end in 'under-Wychwood' or east to Stonesfield, where the shallow diggings for traditional Cotswold slates are still visible in the fields.

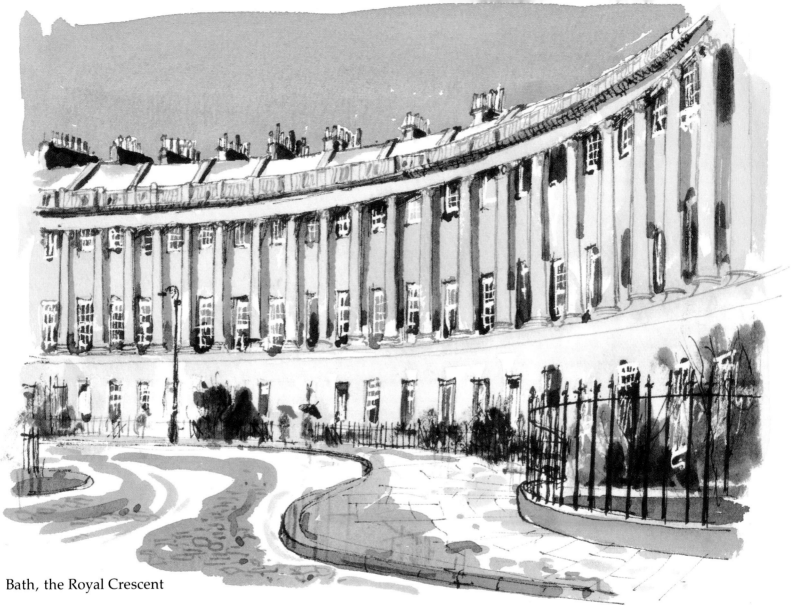

Bath, the Royal Crescent

That Bath is a Cotswold town is proclaimed by the stone from which it is built. The city stands a little way from the hills, but it is a reasonable claim that the escarpment has its southern end at Little Solsbury Hill just outside its limits. The point is that Little Solsbury Hill, like all the rest of the Cotswolds, is made of the same stone from which Bath at one end and Chipping Campden at the other are built. In the little towns and villages we see that stone used to make cosy pictures; in Bath we see a grand design – one of the most famous and consistent townscapes in the world.

The Royal Crescent was not part of the first wave of eighteenth-century construction by John Wood, the Yorkshireman who loved Palladianism. It was the work of his son, John Wood the Younger, who was born in 1727, the year his father settled in Bath. The son built the Crescent, a grand sweep of thirty houses, between 1767 and 1774. And it must have been even more remarkable when new, for it looked straight on to open fields. Now it gazes over the mature timber of Royal Victoria Park. The first house in the Crescent is owned by the Bath Preservation Trust and is a museum of the city's eighteenth-century life. This extraordinary city remains in continual need of defence against threats to its unity and completeness.

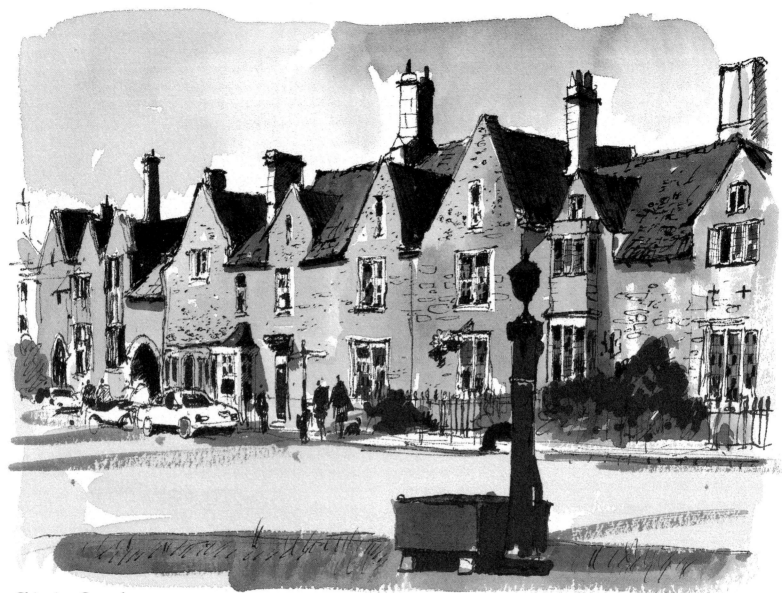

Chipping Campden

The wealth of the Cotswolds today is obvious; there is no part of England where you are more likely to meet Sloane Rangers weekending. So it is easy to forget that the original wealth of the district came on the backs of sheep. A glance at the great church here, endowed by wool men, should be reminder enough. But, after wool, the town was relatively run down. Even the railways did their best to avoid it, passing only through the valley below. Yet the town still speaks of the money which went into building it.

In 1904 C. R. Ashbee transported his Guild of Handicrafts here from the East End of London and a silversmith descended from one of these pioneers still works in the town. By all accounts the arrival of these Cockney craftsmen provoked a considerable culture-clash in the small and backward community Chipping Campden had become. The concern for the local environ-ment which they helped generate is one of the reasons why the Campden Trust, founded a quarter of a century later, was so successful in buying and conserving important houses. The trust's leading light was F. L. Griggs who did much restoration work in the town and designed its War Memorial cross.

In all, the place is less a tourist trap than Broadway or Burford, though quite as beautiful, indeed street for street consist-ently more so.

Lower Slaughter

Bernard Miles (later Lord Miles), who went on to become actor-manager of the Mermaid Theatre, came this way in 1944 seeking a location for the film he was about to make. It was a wartime propaganda movie, designed to show how the British welcomed refugees. Miles had decided to make the point in the form of an allegory – the story of a pair of rare birds which come to nest on a tank-training ground somewhere in England and are enabled to rear their young through the kindness of military bureaucrats, soldiers, clergymen, schoolboys and assorted but 'typical' villagers. Some of them still live in Lower Slaughter for which Miles fell instantly and which he made into the 'Lipsbury Lea' around which *Tawny Pipit* was shot.

What more to say of this most loved and famous of villages? In painting the boldly red-bricked mill, dating from the early part of the last century, John Tookey has avoided the obvious – the village street down the middle of which runs the stream crossed by low bridges. But its charm is undeniable and it is at least possible to follow the path on one side of the stream and admire the stunning cottages without having to dodge the traffic.

Stunning cottages, but more than somewhat self-conscious. They are mostly genuine enough and the older ones go back about four hundred years. But the late David Verey who, besides serving as High Sheriff of Gloucestershire and as the government's Senior Investigator of Historic Buildings, wrote the Pevsner volumes on the county, remarks that some of the cottages 'have been altered or built with the intention of giving them seventeenth-century features; even the council houses have traditional Cotswold stone roofs, an almost unheard of extravagance in other parts of the county'. But in a village like this even council houses, especially with trad, tiled roofs, are now sold out of the community and become weekend homes. An old person's bungalow went for a six-figure sum in Burford the other day. Perhaps the National Trust will buy a council house or two so that our grandchildren can admire these quaint workingclass homes.

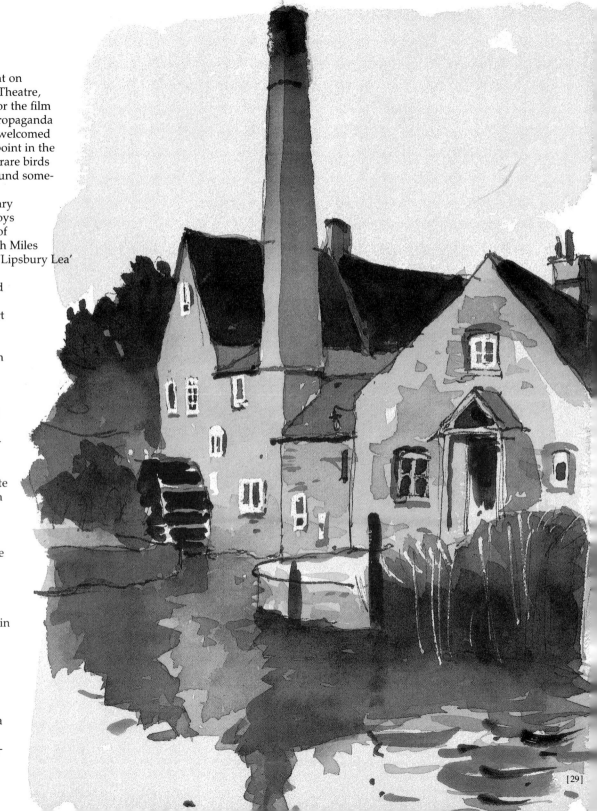

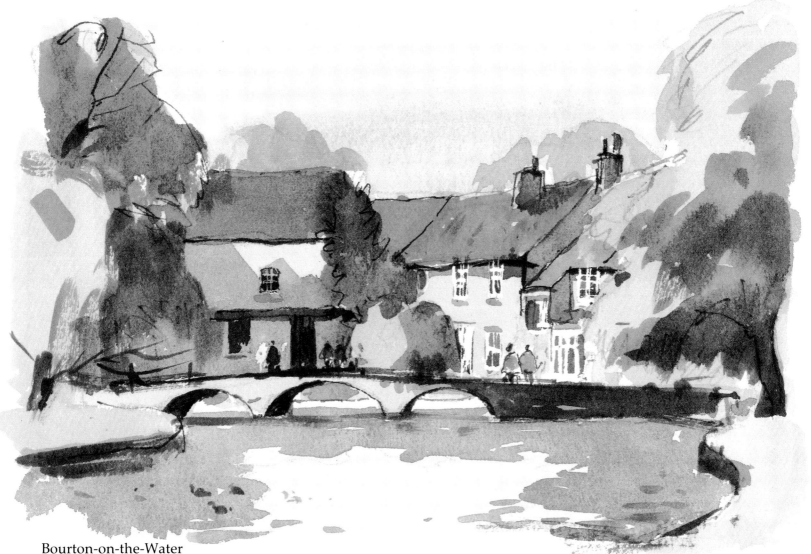

Bourton-on-the-Water

The young Windrush runs under a series of charming footbridges.
The golden houses line the street of which the river is the central
reservation. In a competition for the most photographed or visited
village in England, Bourton is near the top, in fact *over* the top.
Those who love Cotswold villages come here out of season, just
after sunrise, and try to close their eyes to the excesses of tourism
around them. Apart from the take-over of houses by shops and
eateries, Bourton suffers a model railway (the real one was closed
years ago), a model village (but isn't Bourton just that?) and an
exhibition of village life (to tell us how it was). And round the
corner are the exotic Birdland Zoo Gardens. When all this palls,
seek out St Lawrence's Church, which needs nothing but its own

history to detain the visitor. The original church was replaced
(except for the fourteenth-century chancel) by a Georgian one in
the eighteenth century. This was in turn destroyed to make way
for a Victorian building, but again they saved the chancel – and
also the Georgian tower. How taste changes. David Verey in the
Pevsner guide loves this *mélange*. 'Exceptionally beautiful',
'sensitively detailed' and 'truly magnificent' are the phrases he
applies to the Victorian church, the 1890 south porch and the 1891
king-post roof respectively. Novelist John Moore walked this way
in the mid-1930s in the course of hacking out a travel book. For him
the church was 'an abominable mixture of bogus Gothic superim-
posed on what was probably a delightful Georgian building'.
Choosing which to believe will surely be more fun than 'Birdland'.

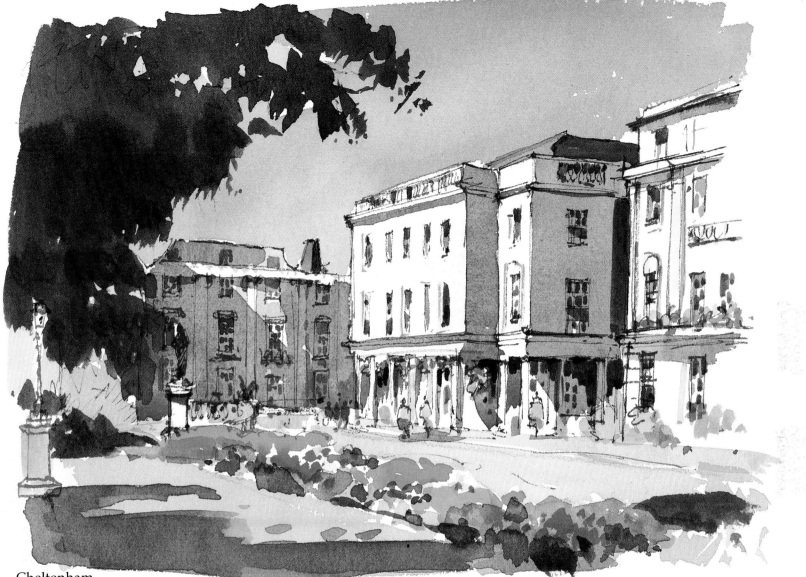

Cheltenham

To show that there is no accounting for tastes, let it be recorded that William Cobbett found Cheltenham 'a nasty ill-looking place, half clown, half cockney'. So much for a fine Regency town. The health-giving spring waters had in fact been pumped and marketed since 1760; the man responsible, Captain Henry Skillicorne, enjoys what is said to be Britain's longest epitaph (nearly six hundred words) in the parish church. But the place did not truly get moving until George III and family came to stay in 1788. Then as now the royal seal of approval worked its enterprising magic and the Regency town of long white terraces and elegant squares sprang up.

Very urban, but also very Cotswold. Far more health-giving than any mineralised spring are the great breezy open spaces which stand within an afternoon's walk on the western side of the town. Greatest of these are Cleeve Hill and Cleeve Common where the escarpment reaches over 1000 feet. You can follow it by the Cotswold Way to Leckhampton Hill and the Devil's Chimney (see p. 55).

Colonels, the Ladies' College and GCHQ are Cheltenham's images for most of us. But tucked away in Crescent Place lives the Countryside Commission which, among other good deeds, done despite ever-inadequate finance and feeble powers, designated the Cotswolds an officially protected Area of Outstanding Natural Beauty – of course it was always so, but these days needs all the help it can get.

Burford

Those of us who live there suppose this to be the antique-shop capital of Britain. I have better things to do than count them, but I am told we have at least twelve and I know that only the other day our excellent ironmonger retired and his shop immediately became another. This is what comes of being a gateway to the Cotswolds and hyped as such. This is what comes of having a still heart-catching main street sloping down to the Windrush and this is what comes of being the all-England model for small towns (or so said John Piper, no less).

Down by the Windrush, surrounded by meadows, buttercups and cows, the town has arguably the most idyllically sited car-park in the country. The churchyard and Burford's lovely spire are adjacent. The car-park is free, but the problem is getting anyone to use it. They all want to park on the street and as the street is a very main road (Brum to Southampton) there is chaos.

Never mind, there is much to see. Don't miss the tremendous church where Cromwell had three Levellers shot because, sensible chaps, they didn't want to go to fight in Ireland. In consequence, Burford has become a place of annual pilgrimage for socialists who celebrate the Levellers as ideological ancestors. I'm not sure they were, but the Morris men come too and we have a party. The best view of the town is from the quiet garden of *The Countryman* magazine's office on Sheep Street (always open).

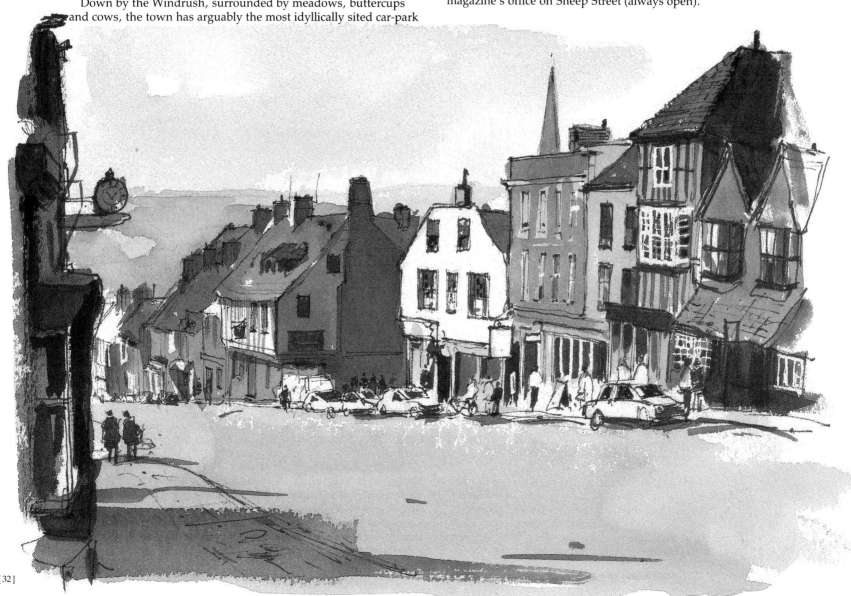

Bliss Tweed Mill

And what, you may well ask, is this? It doesn't look like much to do with the Cotswolds, yet here it is in a valley just outside Chipping Norton. The designer was a man called George Woodhouse who came from Lancashire and there is more than a touch of brassy northern grandiloquence about the whole thing. It is made to look like a country house rather than a mill, but you can't get away from that chimney-stack (Tuscan order and rising out of a great dome).

The Bliss family were tweed millers in Chipping Norton for a long time, their firm being established in 1746. They had their mill rebuilt after a fire in the 1870s and this is the result. But the firm closed in 1980 and that is when the headaches began. What to do with such an object? It is not as if you can just chuck away an unwanted mill these days. There is the industrial heritage to think about and we had all got rather fond of the thing over the last century and a bit. There were all sorts of suggestions, kept the letters-to-the-editor columns busy for years in more than one local paper. But among all the ideas I never saw anyone suggest that the mill be razed and the space returned to farming.

Well, you've probably guessed the outcome. The exterior of the mill *will* survive, but inside will be very desirable residences. The irony is that the Bliss family also brought the railway to Chipping Norton, a useful rather than a striking object. It has sunk, unconserved.

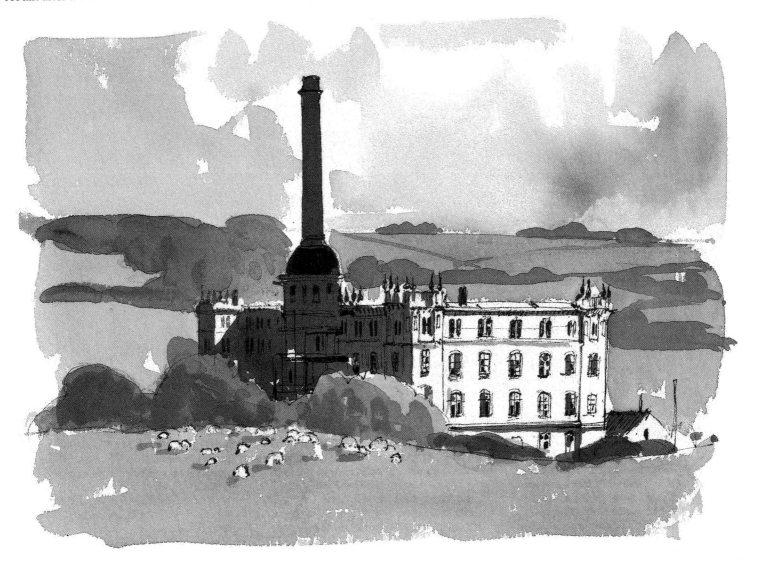

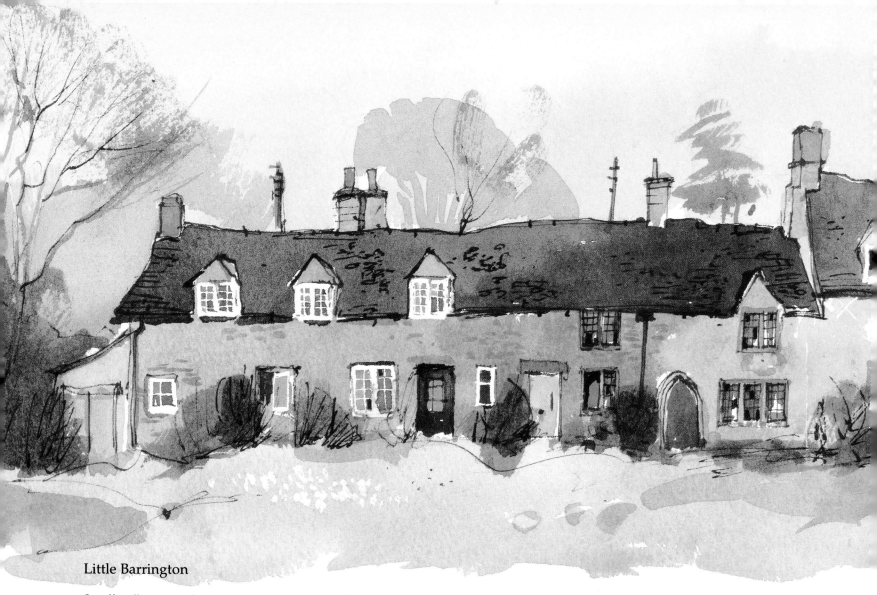

Little Barrington

Scruffy villages are about as common as golden eagles in the Cotswolds. The norm is smart new paint, blazing flower gardens and neo-Georgian front doors (if the planners will let you get away with it) – all reflecting an upwardly mobile population. So Great and Little Barrington, lying respectively north and south of the Windrush, just before it leaves Gloucestershire for Oxfordshire, are a refreshing surprise. There are more than a few decaying cottages and barns. The biggish green in front of the row above is weedy and unkempt except for the browsing of a couple of ineffectual goats. It can't be long before some do-gooding Barringtonian takes his neighbours in hand and enters them for the best-kept village competition. How, he or she will demand, can we hold up our heads before our immaculate friends in Burford and Taynton down the river?

A bridge across the Windrush by the Fox Inn links the two Barringtons. Leaning on it and watching the opaque, muddy water slide slowly away beneath, you wonder whence comes this rushing wind of a name. That is of course a misconception: 'wind' is probably *gwyn* which means white in Welsh and 'rush' is probably *reisko* which meant a marsh in Old Celtic. Thus one of the most poetic names in English topography is analysed into something mundane. So we had better treasure the romantic untidiness of the Barringtons, big and small – they don't come that way any more.

Minchinhampton

A big but reasonably compact village. It belongs economically to the Cotswolds' industrial complex, which includes Stroud, the Golden Valley and neighbouring Nailsworth, all places whose fortunes were founded on the woollen trade. But Minchinhampton is not without architectural good looks. Even the High Street, despite the inevitable repetition of commercial fascias from every other high street, remains a handsome affair. There is a typical Cotswold market-house from the late seventeenth century and the church is one of the most curious anywhere. Its spire was cut down to its present height in 1563 and was then given a coronet of stone. Very odd.

But you must leave the village and explore Minchinhampton Common which is owned by the National Trust on the north-west side of the settlement. You pass the Bulwarks to get there. These are the remnants of a once-immense Iron Age fort which is thought to have defended more than 600 acres. The common itself comprises 450 acres and is still used for grazing and, more perilously, for golf. Other earthworks occur on it: the Cross Dyke, Amberley Camp, Pinfarthing Camp, Whitfield's Tump (a long barrow named after the Methodist George Whitfield who preached from it) and Pillow Mounds. Of the last there are some forty, but the experts say there is nothing prehistoric about them; they are probably medieval artificial rabbit warrens.

A piece of almost forgotten literature happened here too. Mrs Craik (Deborah Maria Mulock) wrote much of a famous piece of Victorian sentimentality, *John Halifax, Gentleman*, while staying at Rose Cottage on the edge of the common. Indeed, the cottage is supposed to be the model of the one in which hero John first encountered Ursula March. Although the novel is set around Tewkesbury, this common is the model for its Enderley Flat: 'Such a fresh, breezy spot – how the wind sweeps over it! Shouldn't you like to live on a hill-side, to be at the top of everything, overlooking everything?' Up here they still do.

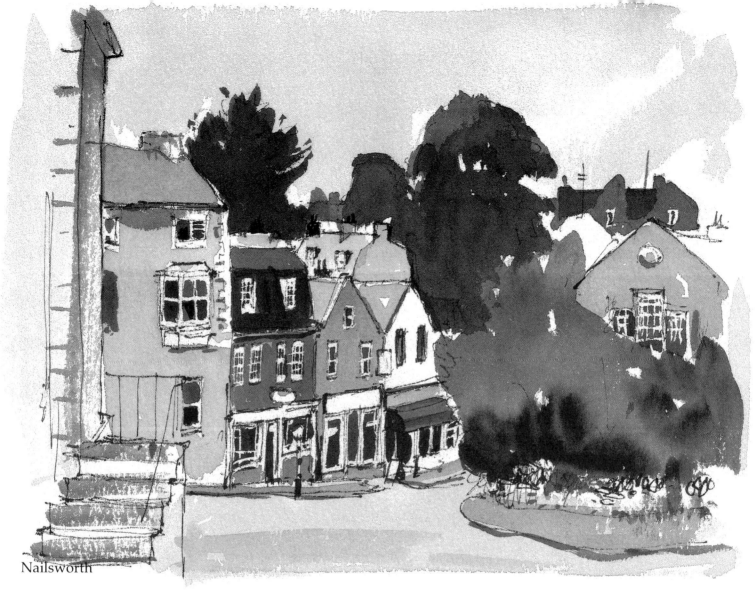

Nailsworth

Somebody in this town had a macabre sense of what is fitting. In the centre is the clock-tower dating from 1951, said to strike so as to be heard in surrounding villages. But it is more than a clock – it is also the war memorial. Who wants such an hourly reminder? 'Never send to know for whom the bell tolls . . .' And this is a town (or is it a village?) where you must seek out the bits with charm. In many ways it resembles neighbouring Stroud: originally a place built on the economy of woollen mills now closed and so diversified into other activities. The mills depended on fast-running water for power and that means steep hills. Main streets don't come much steeper or busier than Nailsworth's. But the famous killer to which all the guidebooks direct you (so we may as well

too) is Nailsworth Ladder, the steepest street of them all. And while you are there, do a bit of trigonometry and measure the gradient. Nobody seems able to decide whether it is 1 in 2 or in 2½.

Now for a few corners of surviving interest. On Spring Hill are grouped the houses of clothiers who made it and Spring Hill House has a good eighteenth-century front . . . and, guidebook at the trail, you can go on. But this is rather a place for spotting the socio-economic subtleties. The church, an indifferent one, has contemporary murals incorporating portraits of the local brass band. We are nearer to the culture of a Yorkshire wool town than Cotswold.

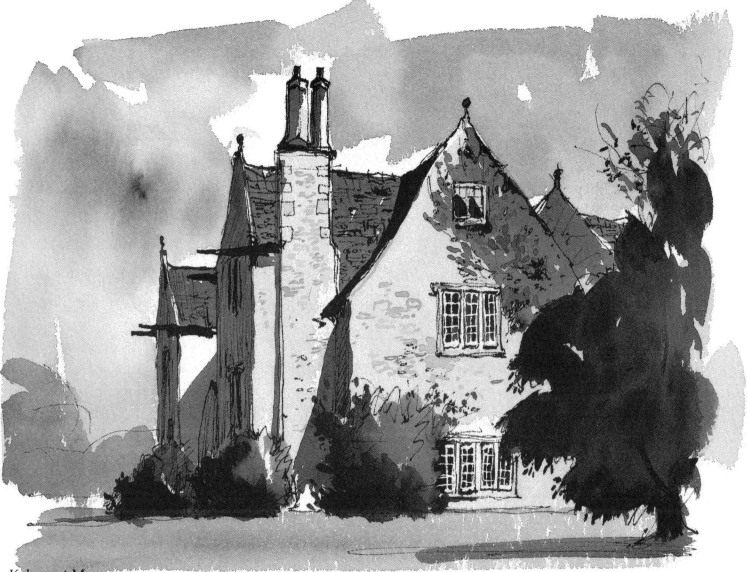

Kelmscot Manor

Plan your visit carefully. Kelmscot Manor belongs to the Society of Antiquaries and their tenant opens it to the public for only thirty hours a year, that is to say for five hours on the first Wednesday of April, May, June, July, August and September. But if you can fit into this Procrustean schedule, you will be rewarded: the house inside is much as when Morris lived here (1871–96). You can see the 'cabbage-and-vine' tapestry which he wove; there are works from the Kelmscot press and furniture too, all redolent of his reverence for medieval craftsmanship. Among houses to view, this is not that remarkable: grey stone, a gabled entrance and a curiously tall north wing at right angles to the original (circa 1570)

building. The roof is full of what Morris called 'strange and quaint garrets among the great timbers'.

This is the house in which Morris's novel of a Utopian future, *News from Nowhere*, ends when the dream of a better world dissolves. You can come to it, as the teller of that story does, up the Thames which flows nearby, but on the water you must mingle with the flashy diesel craft that churn the river. It is pleasanter to stick to the towpath. Morris dreamed of a cleaner and quieter England, but his Thames possessed these qualities when ours, crowded with motorised craft, does not.

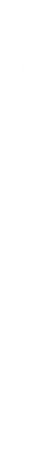

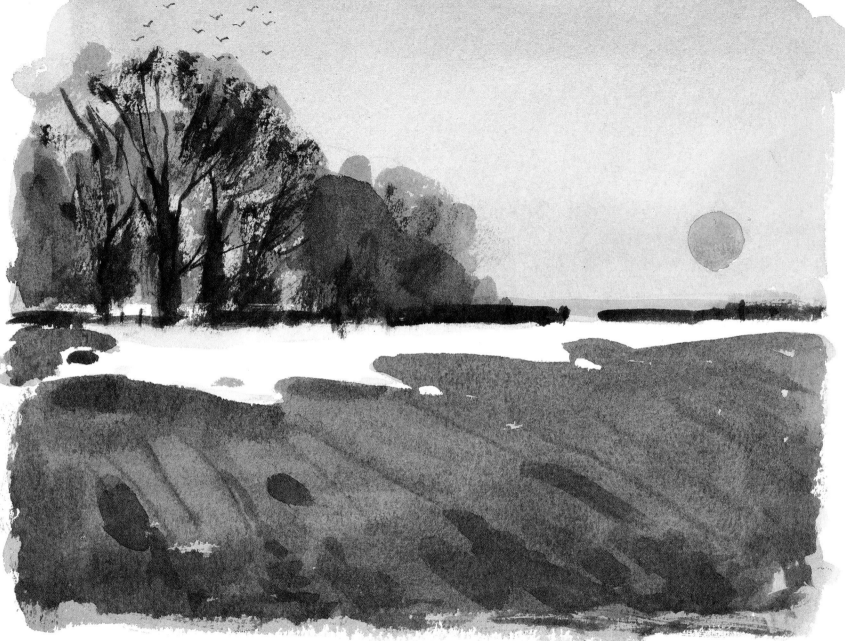

Winter Landscape

Fair-weather summer visitors have a lopsided view of the Cotswolds. Their holiday snaps are of golden stone that glows in the sun, bright sunshades in a pub garden and paddling in the Windrush under an ancient bridge. But note the second syllable in Cotswold. The old English *wald* was a forest, but gradually came to signify the bare hills the word denotes today – and the Cotswolds can be very bare and bleak, often with nothing that could be called a wood for miles, the odd clumps and copses only emphasising the bareness of the rest. The stone walls dividing field from field add no warmth and are now mostly tumbled-down and topped by wire, an extra note of desolation.

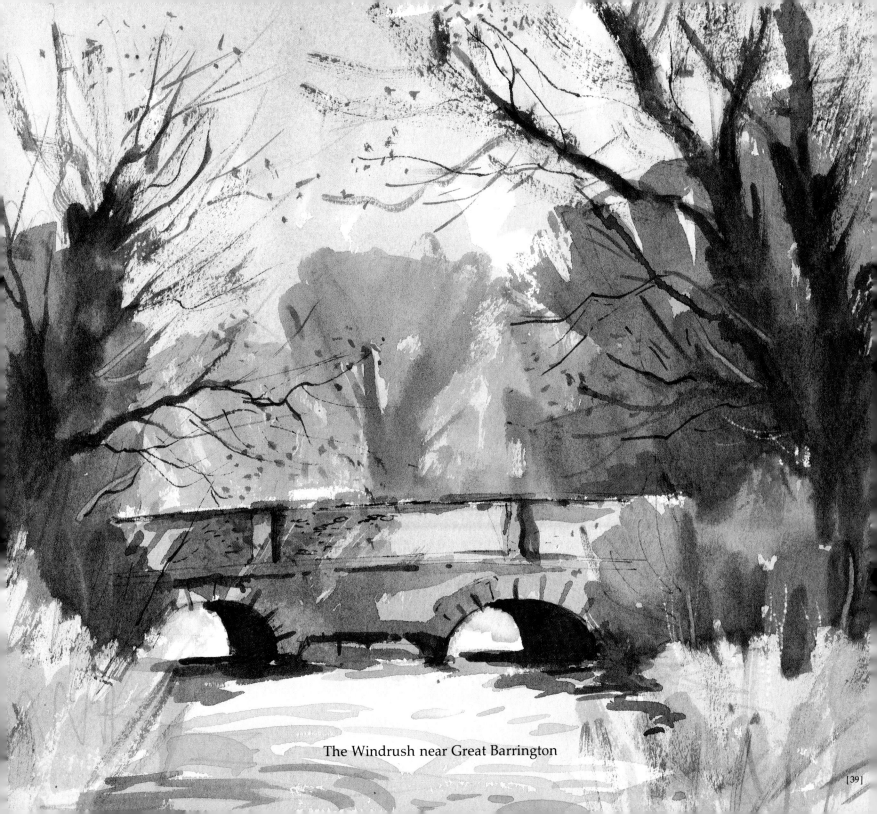

The Windrush near Great Barrington

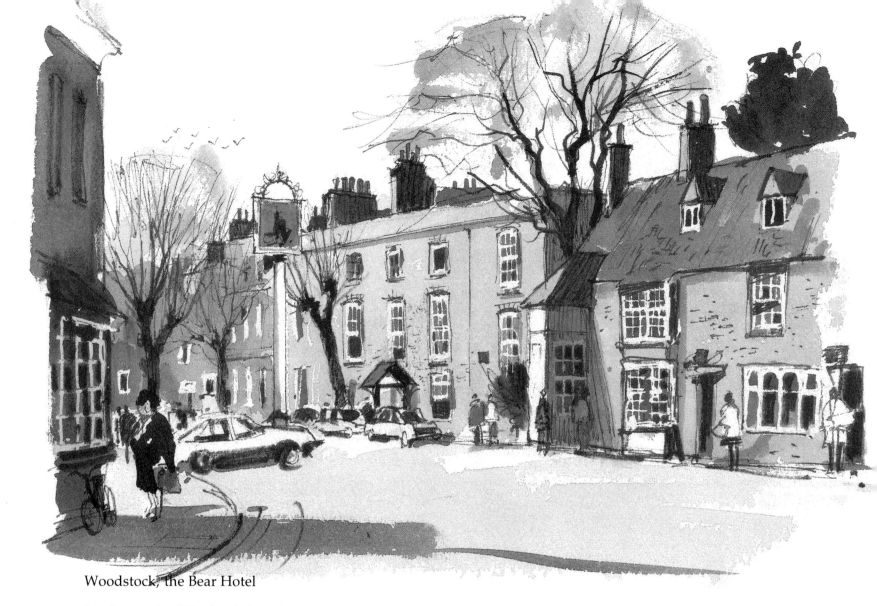

Woodstock, the Bear Hotel

It is the tragedy of Woodstock that it lies on the A34 a few miles north of Oxford. The A34 is the road to Stratford-upon-Avon and thus the little town's fate is sealed: it is on that most infamous of tourist routes, the Oxford–Stratford run. Worse, the road from Oxford is a dual carriageway, so the tourists in their hired cars belt merrily along and, when they find themselves at Woodstock, stop to explore, thinking that they are making good time. Little do they know that the rest of the Stratford road is the kind of winding killer that only the British call an artery.

You must peer hard beneath the frothing entrepreneurial tide of boutiques, antique shoppes and galleries of bad to indifferent art to see that this was once a town of character. It stands at the gates to Blenheim Palace and its park where, despite all, a sense of eighteenth-century calm and rationality prevails (see p. 13), but you will feel no sense of order if you try to park in Woodstock's main street. The Bear Hotel is an architectural mishmash but reminds us that visitors once arrived less comfortably but in more manageable numbers.

Just before you go, pop round the corner to the Oxfordshire County Council's Museum, an unobtrusive but effective place, which will tell you more in ten minutes than all the shoppes living off Woodstock's past will in a week.

Broadway Tower

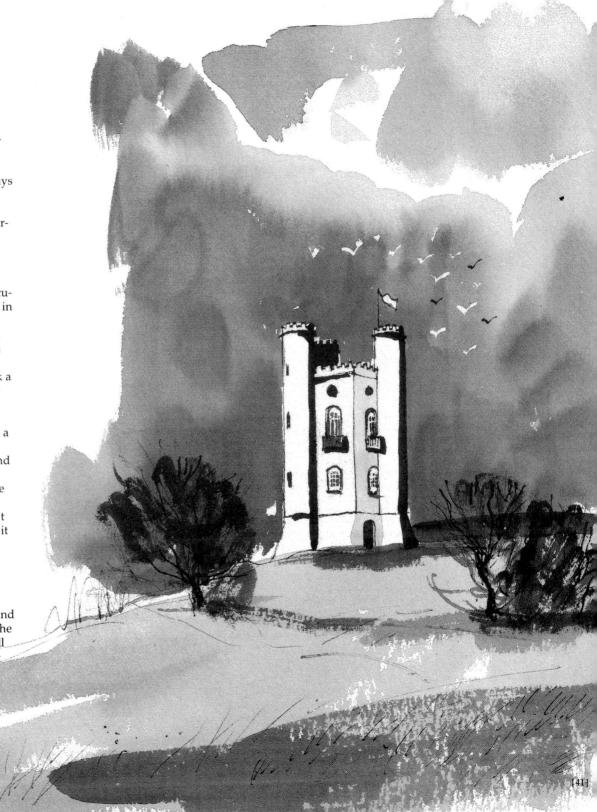

In the days when motorcars were less mechanically predictable than they are now, Broadway Hill was a favourite spot for hill-climbing trials. The road out of Broadway village at the foot of the escarpment is both steep and twisty. At every bend you are enjoined not to exceed 25 mph; and coming down, handy escape bays for 'runaway vehicles' cause the rashest to dab their brakes. At the top of the escarpment is Broadway Tower and its surrounding country park.

This is the second highest viewpoint in the Cotswolds (1024 feet above sea level); Cleeve Common above Cheltenham goes higher. The views are accordingly spectacular. That first big lump is Bredon Hill and in a direct line beyond, given the proverbial clear day, is the profile of the Malverns, a miniature mountain range dumped into a prosaic midland plain. Beyond them are Offa's Dyke and the Hengest Ridge. Look a little north and you should, on all but the dullest days, be able to locate Pershore Abbey and Worcester Cathedral.

The park itself is not so much a park as a concentrated induction-course to the Cotswolds – their wildlife, countryside and crafts. Have a look here at the dry-stone walling, since you won't see it being done in the fields any more. As to the tower, John Tookey has done his best, but it isn't the most prepossessing of buildings. But it carries a pleasant tale. It was built by the Earl of Coventry for his wife ('I've got a tower for you, dear,' did he say?) in 1799 when they did such things. She was a Cotswold lass and condemned to live in exile from her native hills with her husband miles away at Worcester. But one night she saw a bonfire on the top of Broadway Hill (which the Earl happened to own). So he gave her the tower as a permanent reminder of home, always visible – on a clear day of course.

Stroud

An autumn picnic on the grass is more gracious than typical of Stroud. The town itself, its neighbours, Stonehouse and Nailsworth, and the Frome valley in which it lies form the most obviously industrialised area in the Cotswolds, the one or two big towns apart. The Frome was the motive power for the mills which made the Golden Valley famous for cloth. The sheep off the hills provided the wool and, by a further stroke of industrial fortune, neighbouring springs produced the salts needed for cleaning and dying the cloth. The area's most famous products were perhaps 'Stroudwater scarlet' and 'Uley blue' – cloths which went all over the world in military uniforms when such bright things were worn.

The river and its inflowing streams were driving 150 mills in the early nineteenth century, but then came depression and a shift of woollen focus to the north.

As in many industrial towns with a past to preserve, the impetus for conservation came late. Stroud has lost some of its finest mills and many good clothiers' houses. But the pattern of the old woollen town is still there, unceremoniously squashed into the bottom of the narrow valley whose river was its lifeblood; streets climbing the valley-sides steeply, satellite settlements fingering up the joining valleys.

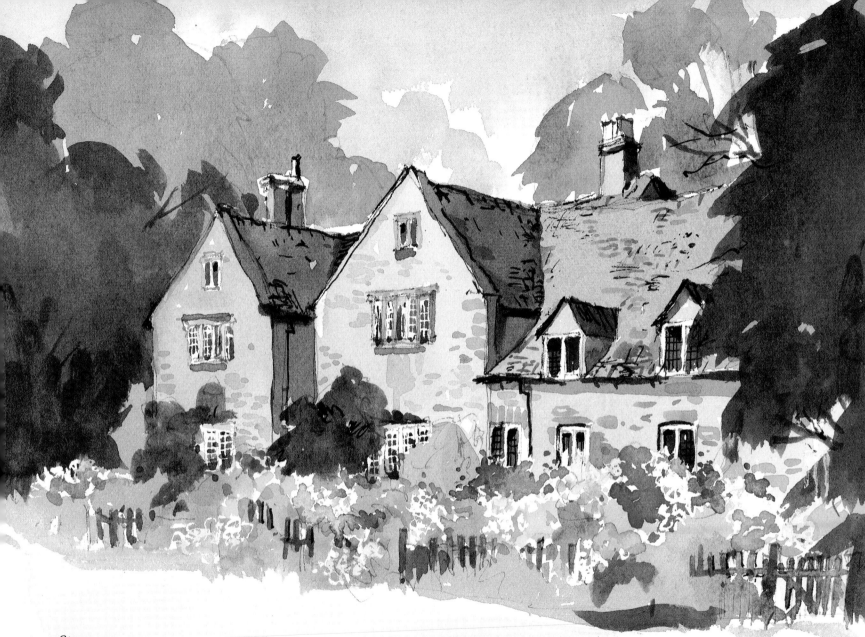

Stanway

Along the foot of the scarp south-west of Broadway, runs a string of delectable villages, snugged into folds of the hills, girt by great woods, their gardens full of bright flowers. Stanway is one such and nowhere does the pale stone show better than in the memorable grouping of manor house, church, manor gatehouse and tithe barn. In the mid-1930s that almost forgotten pioneer of 'green' thinking, H. J. Massingham, thought this small acreage gathered together 'the repose and graciousness of old England'. That may be laying it on a bit thick, but if you go there you'll see what he meant. And he added – just to remind you that a summer picture does not tell all – that 'the scene is yet more moving in winter when the bloom of the grey stone is seen against the dark network of branches and the subdued greens of Stanway Hill'.

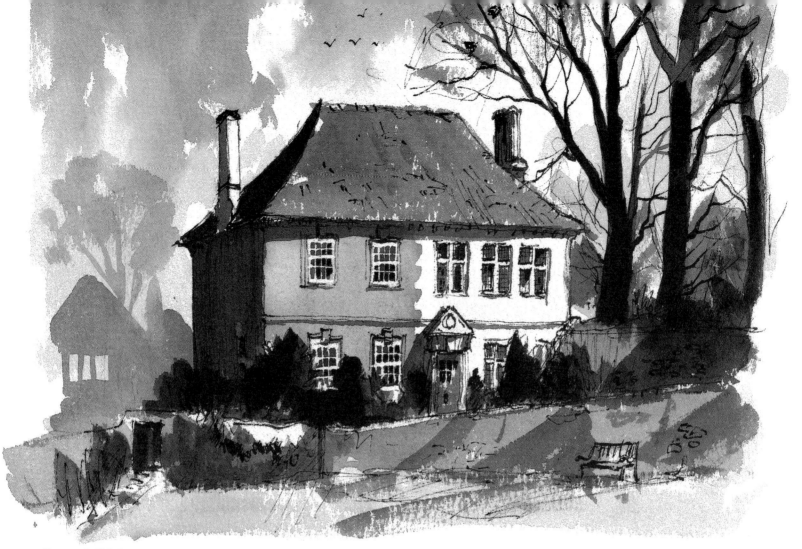

Snowshill Manor

A few miles up the escarpment from here, the National Trust owns the gardens of Hidcote Manor, famed for their formal beauty and the order and elegance which their one-time owner created there. In Snowshill Manor, equally in the trust's guardianship, we have the creation of a plainly disorderly (or at least highly eccentric) mind. Not that Charles Wade lacked gardening talent, although it ran to cottage gardens rather than disciplined beauty.

But Charles Wade (1883–1956) was primarily a collector, indeed a whole lot of collectors rolled up into one person. What did he collect? Better ask, what did he not. Here are gatherings of bicycles, toys, clocks and locks and keys, compasses and telescopes, musical and scientific and domestic instruments and objects, lace and heaven knows what. There are touches of the east – oriental furniture and the armour worn by Japanese samurai (said to be an unsurpassed collection). The official trust guide remarks tactfully: 'Charles Wade's tastes and interests, if not always marked by discrimination or strong aesthetic judgement, were astonishingly wide and eclectic.' Just so.

Wade acquired the house in 1919. He lived austerely, largely in a nearby converted barn. He did not have electric light. He spent his Caribbean sugar fortune on collecting. Faced with these odd riches, don't neglect the house itself, a plain and characteristic Cotswold manor, dating mostly from the seventeenth and eighteenth centuries, though perhaps originally medieval.

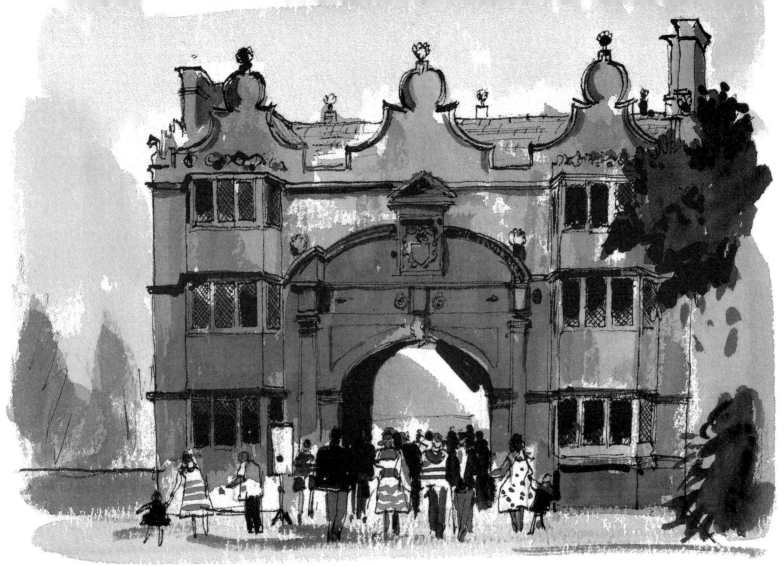

Stanway House

Through this arch lies the Tudor manor house of Stanway, but the gatehouse is a remarkable building in its own right. It is believed to have been built somewhat after the house, around 1630, and was for a time attributed to Inigo Jones. It is positioned at right angles to the house and has a high wall immediately to the right (as you look at the picture), which some commentators find awkward. But it has surely been there long enough for any infelicity to have been dissipated by time.

Those ebullient gables are topped with scallop-shells, echoing the arms of the Tracy family who built the house (having acquired the manor from the Augustines of Tewkesbury at the dissolution). All the pundits rate the house high, especially Viscount Norwich who calls it 'one of the loveliest houses in Gloucestershire – and one of the most desirable ones I know anywhere'. The great hall is superbly lit by big west and south windows.

Older than the house is the tithe barn, fourteenth-century, cruck-framed with massively braced walls. This was built for the monks of Tewkesbury. It is still in use as a theatre and hall. Some years ago I addressed a meeting of the Gloucestershire branch of the Council for the Protection of Rural England in it and can attest to the excellence of the acoustics.

From big house to cottages, via a mid-seventeenth-century vicarage, Stanway is full of good things of the great, the small and the middle sort.

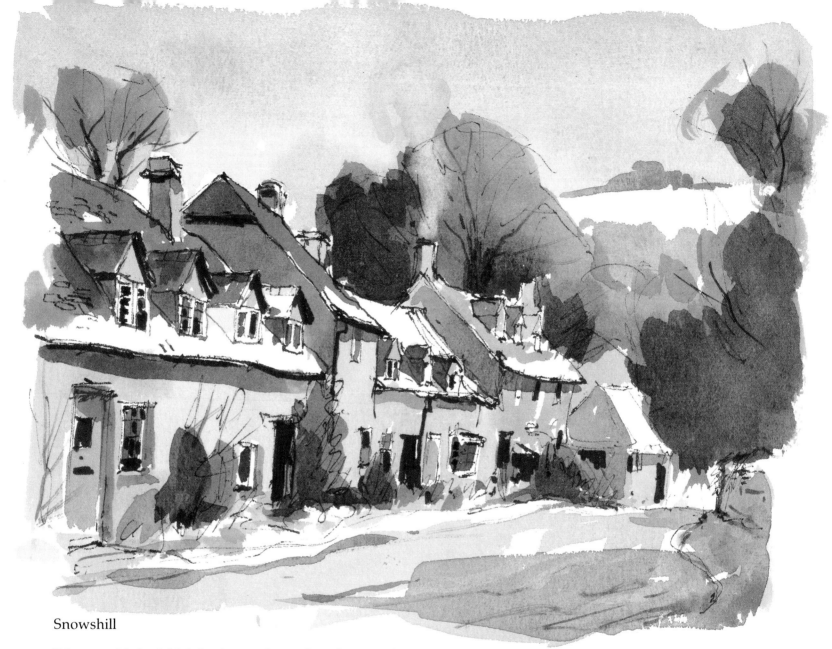

Snowshill

Take your pick, but I think the time to take a walk on the Cotswold escarpment is on a blowy May day when the cumuli come bowling in from Wales. And there is no snugger village to start from than Snowshill. It needs to be snug for it is sited oddly close to the very top of the scarp face instead of down on the spring-line like most of the villages hereabout.

Four minor metalled roads lead in and out of Snowshill and as many footpaths and bridle-ways. Drop down by paths then from Snowshill to Buckland with its marvellous rectory which includes a stained-glass window of the fifteenth century; then take the path along the contours of the scarp to Stanton, a very pure Cotswold village consisting essentially of a single street which will lead you uphill to the Cotswold Way. By this and other by-paths you may return to Snowshill over Shenberrow Hill and so complete an exhilarating six-miler.

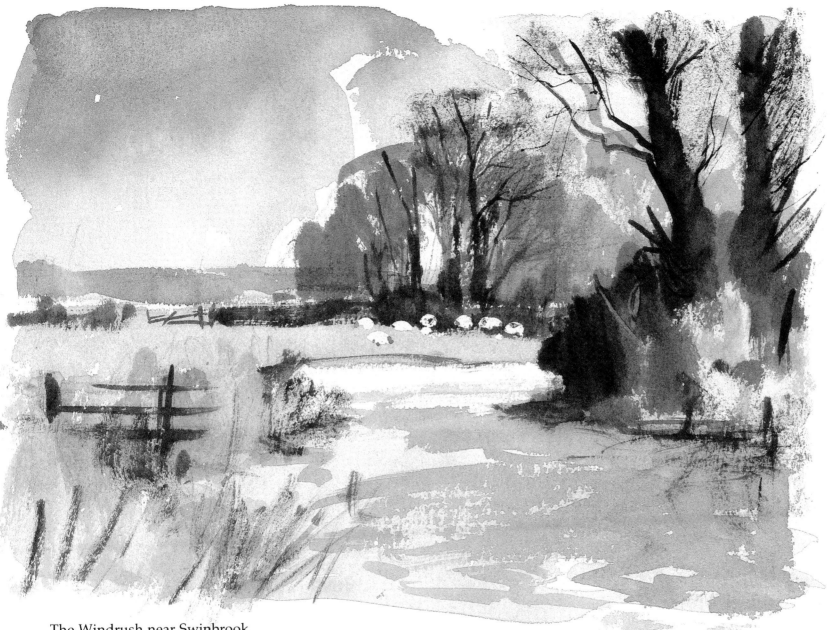

The Windrush near Swinbrook

You are in luck here because there is a public footpath beside the river through these meadows. It joins Burford to Widford to Swinbrook and on to Asthall – about three miles. But this is disgracefully rare, on other Cotswold streams as well as the Windrush. Above Burford there is no path beside the river to the Barringtons. Below Asthall the riverside way is again lost. On the Evenlode and the Leach and the Coln, things are much the same.

Intermittent bits of sheer delight and then a deviation across fields where the path has been most likely buried under crops.

Would it be too much to ask the local councils, which are for ever selling the Cotswolds to tourists, to put some money into creating new riverside walks? Perhaps we could start with a Windrush Way. Quite a lot is already there, but it is the missing links that matter.

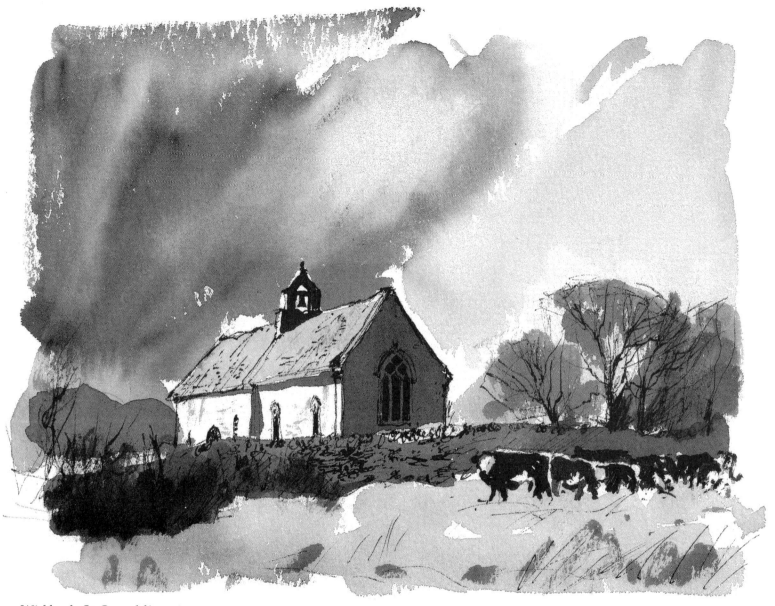

Widford, St Oswald's

There are more cows than congregation here, for services are now rare. Widford itself is at the most only a handful of dwellings. The church can be reached only by footpath on the way to Swinbrook across the fields from Burford. Unlike churches close to houses I have never found it locked. It is an extremely simple building, the pitched roof covering both nave and chancel. Just inside the latter, to the right, is a fragment of Roman mosaic suggesting that this was a villa site. It is at least good evidence of human activity, profane or sacred, on this spot in the middle of the field for a couple of thousand years. There is a thought to carry out into the sunshine. The path leads upstream by the Windrush to Burford or downstream to Swinbrook. Signs on the stiles proclaim that 'Land-owners welcome caring walkers,' so you should have no trouble exercising your right of way, which is hereabouts probably a good deal more ancient than the ownership.

Hook Norton, Brewery

This is a shrine – tread softly. John Piper,
with more taste than reverence, described
the home of Hook Norton ales as 'an extra-
ordinary essay in brick, ironstone, slate,
weatherboarding, half-timber and cast
iron', which leaves little to be said, except
that pilgrims from the entire English-beer-
drinking world come here to taste the taste
over which real-ale buffs drool as near to
the fount as may be. I doubt if Michelin
would say that it *mérite le detour*. The beer
itself though admirably strong is too fizzy
for my taste. Old Hookey, the warming
winter brew, is better. *Afficionados* will be
surprised to discover that not every pub in
HN sells Hook Norton beer. Last time I
went to The Bell it was selling some excel-
lent beer, but not Hookey because the
brewers would not supply a free house.

Refreshed with whosever pint, savour
the town. It is a sprawling industrial place.
We are only Cotswold by courtesy here,
having passed beyond the pale golden
limestone of the region proper. The build-
ing stone now is a peaty, tawny brown –
ironstone. Outside the town the landscape
was systematically raped by the Brymbo
Iron Works which arrived here in 1896.
They have gone now, but the gouging of
the excavators and the kilns in which the
ore was calcined (to remove water) to make
red oxide (for use in the purification of coal-
gas) can still be seen, lapsing now benignly
into the realm of industrial archaeology.

Whether the church is more or less
impressive than the brewery is a matter for
argument. The church is certainly more ele-
gant and a great deal older, having a
Norman chancel whereas brewing did not
start until 1849. The font is Norman too and
there are wall paintings. The town huddles
around it in an irregular fashion. Its cot-
tages have drawn many commuters and
retired people in recent years and the place
is losing its sense of indigenous com-
munity. But some old weavers' cottages
remain as yet untarted and we may hope
that Hookey is too far from the obvious
magnets to be skirted with plastic industrial
parks and the houses of 'volume builders'

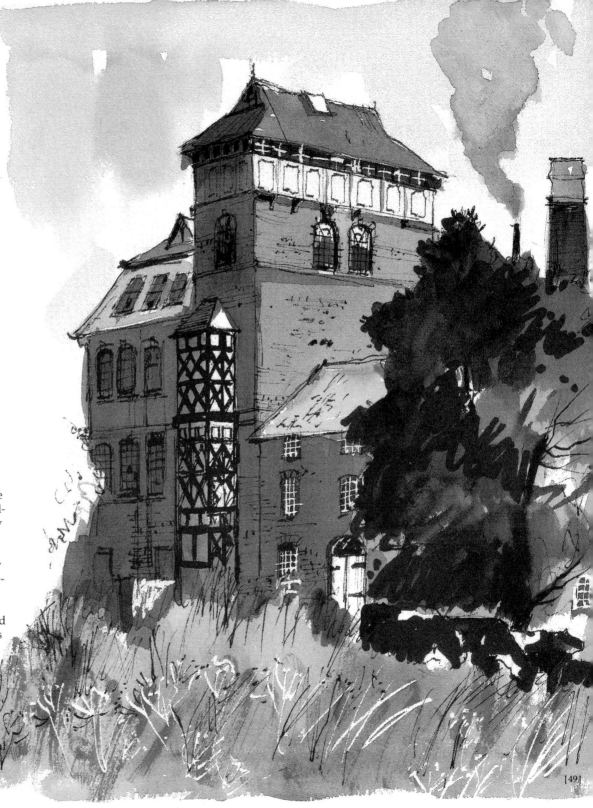

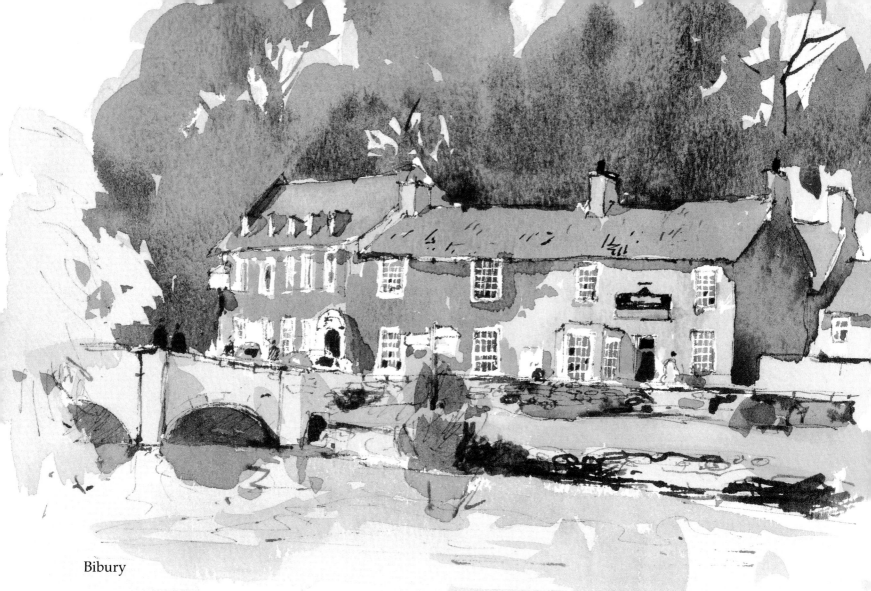

Bibury

The wise have blessed Bibury.

William Morris rated it England's most beautiful village. More recently, that most civilised and knowledgeable commentator on our buildings, Alec Clifton-Taylor, claimed its churchyard as 'perhaps the most enchanting in England'. With these accolades in mind, explore a wealth of good things within a very few moments' walk of the seventeenth-century Swan, pictured here by John Tookey.

The bridge carries an unhappily busy road over the River Coln. This is a Cotswold village-pattern you will recognise at Bourton-on-the-Water, the Slaughters and Eastleach: houses on both sides of the stream which is crossed by unassumingly flat bridges.

St Mary's is worth looking at, apart from the churchyard. There are Saxon touches remaining and more substantial Norman work in the door. There are three good Decorated windows and Perpendicular at the west end. In other words, it is a kind of story-book display of half a millennium of architectural styles which an English village church should be.

Arlington Mill (just a little downstream) is a solidly strong affair of the seventeenth century. But the pearl of all is Arlington Row (in the village), a terrace of weavers' cottages of much the same date and owned by the National Trust. Their higgledy-piggledy charm and easy-going intimacy are qualities we can only envy.

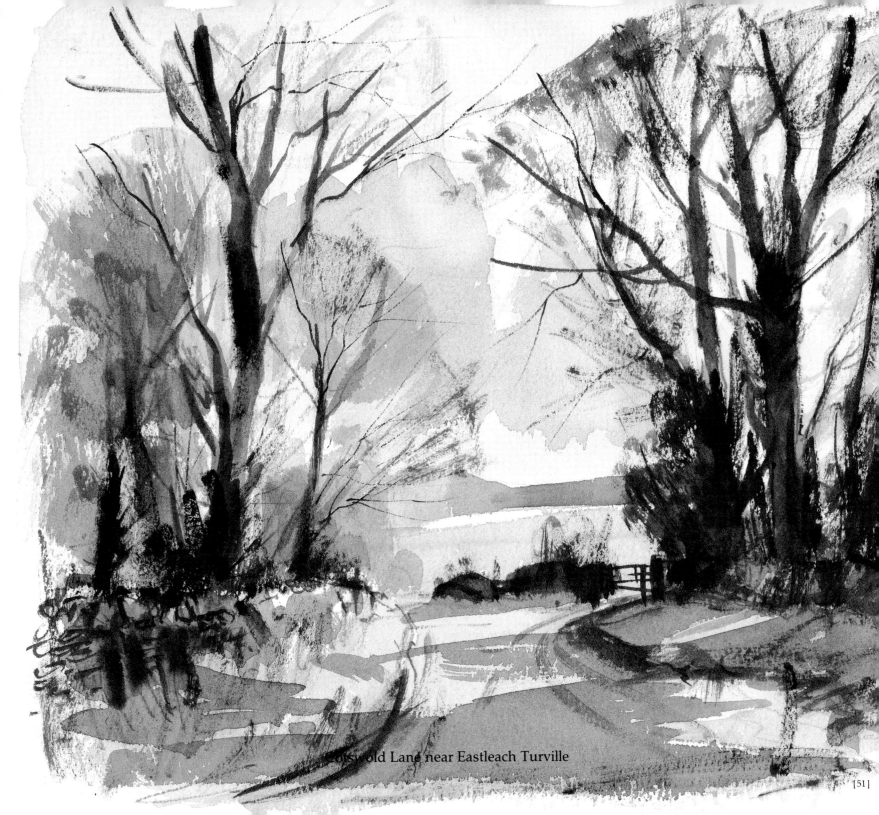

Cotswold Lane near Eastleach Turville

Winchcombe

For unfathomable reasons there are two *police* museums in the Cotswolds, one at Tetbury and one here. Who goes to them? Retired coppers sentimentalising about the older styles of hand-cuff? Old lags, regretting improvements in technology?

More to the point, Winchcombe is the biggest town in this part of the Cotswolds. It is sited in a kind of re-entrant valley running back up into the hills. It is not a particularly distinguished spot architec-turally, although we'll come to its details shortly. But it always sticks in my mind because I first went there armed with a guide-book written in the 1930s – one of those red ones with no author named. Whoever he or she was had this to say about the place: 'Winchcombe is a shining example of a feature which distinguishes the Cotswolds from almost any other part of Britain; namely the manner in which the buildings unfailingly rise to the level of the scenery so that instead of appearing as excrescences on the land-scape they actually adorn it . . .' That is still true despite some unfortunate things in the last forty or so years.

The church is a good one, although not according to the connois-seurs in the first flight for the region. It is less elaborate than the other mighty wool churches. Built around the middle of the fifteenth century it is a splendid piece of Perpendicular. The town used also to have a great Benedictine Abbey just north-east of the church. It went to the Lord Sudeley of the day on dissolution and he dissolved it very comprehensively indeed.

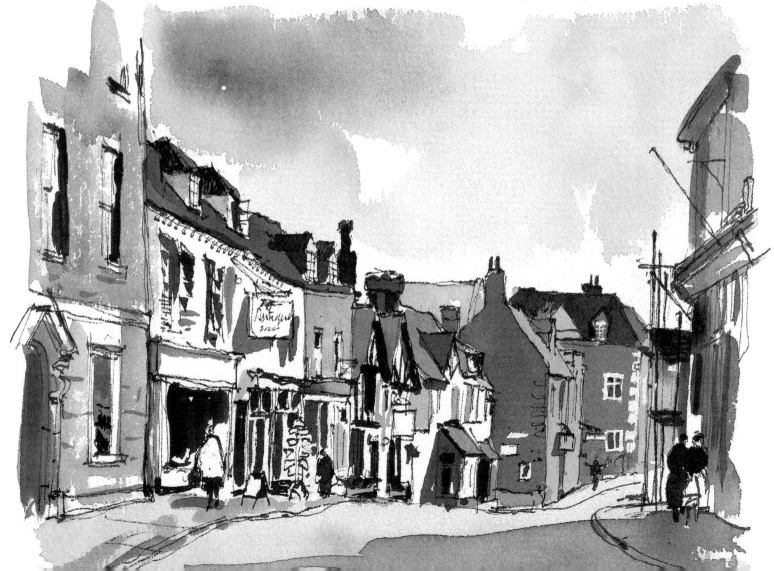

Ozleworth

This will take some finding, for you must penetrate the maze of lanes and paths which lie immediately behind the Cotswold scarp at Wotton-under-Edge to reach Ozleworth. But here are at least three wonders. The church has a hexagonal tower which is most unusual and certainly the only one in this part of the world; it is set in a circular churchyard which is an equal rarity; and among the graves is that – it is said – of the last Englishman hung for highway robbery. All this lies inside a private park. The village itself is almost nothing but was once a sizeable settlement when the fast little streams drove mills and made water-power. The river flowing down Ozleworth Bottom below is just such a stream. When water power was outmoded Ozleworth and places like it decayed.

The tower is the oldest part of the church and no two of its six sides are the same. Next door is the house of Ozleworth Park – eighteenth century and Regency – with terrific views. Again marvellously sited is Newark Park, a mile to the west. Of the original 1540 house only the east front remains. James Wyatt rebuilt it and you won't see much of it without trespassing. What you can't escape seeing is the enormous tower on the hill above the village. It looks like a close cousin of the Post Office Tower in London and that is exactly what it is.

Getting into Ozleworth is a frustrating business for the driver. Steep hills and sharp bends demand total concentration and leave no chance to absorb the extraordinary prettiness of this country-side. Unfortunately, the footpath network is not all it should be. The best approach is along the bridle-way from the east.

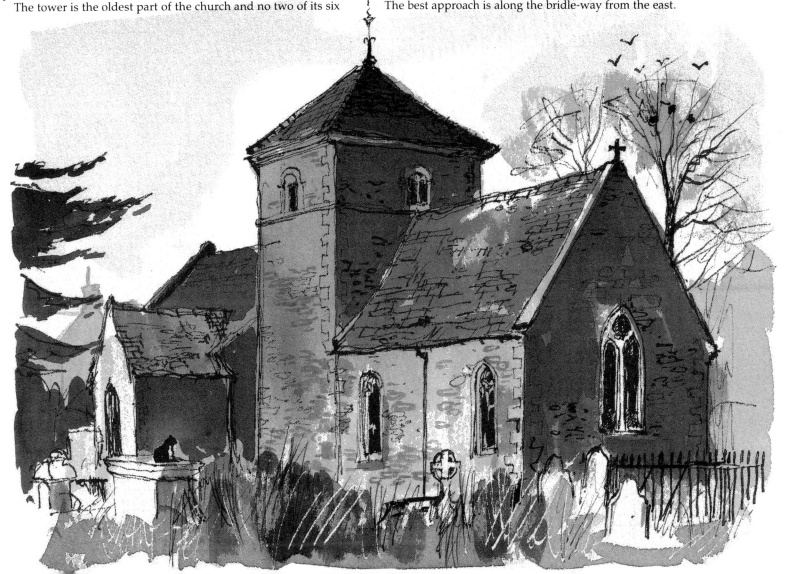

Moreton-in-Marsh Market

The street in which this market gathers is not only the main street of Moreton-in-Marsh, it is also the Roman Foss Way, running ruler straight from Cirencester to Lincoln. The Romans built it on that diagonal axis because it would thus be used to distribute troops and supplies to their frontier which was parallel to the Foss and somewhat north-west of it. It is still a marvellous road to travel. Much of it is not classified or only a B road. It is nearly all straight, but of course there are interruptions because the Romans didn't know about by-passes and places like Moreton were not there to be by-passed anyway.

But the road and the town don't make a bad job of their enforced symbiosis. The width of the main street helps of course. The market when it is in swing and the Redesdale Hall (the market hall) in the very middle make an excellent foil to the rest. The standard of buildings does not average anywhere near as good as Chipping Campden or Burford, but there are some good things: the sixteenth-century curfew tower, the Victorian Tudor market hall. And the Mann Institute which bears an inscription by Ruskin: 'Every noble life leaves the fibre of it interwoven for ever in the Work of the World.'

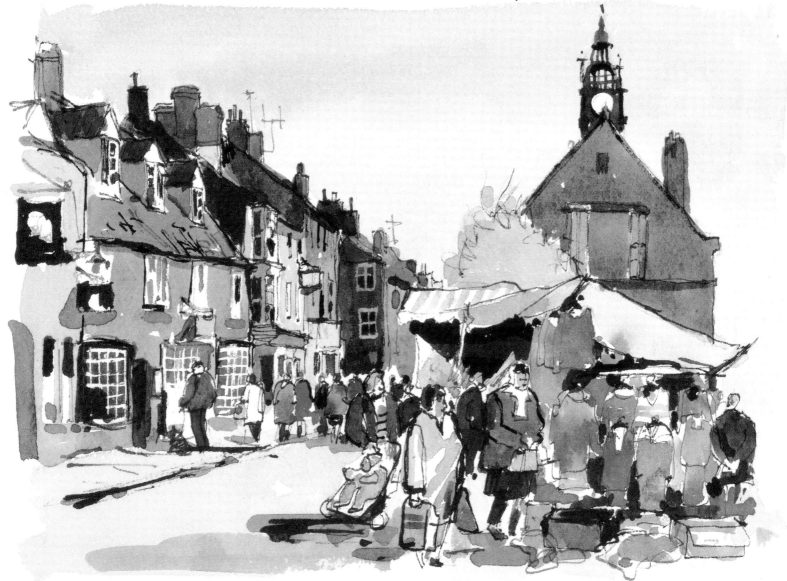

The Devil's Chimney

The Cotswolds possess a long, magnificent escarpment. On their eastern side the hills lower themselves gently, seamed by the valleys of little rivers, to the upper Thames basin; on the west they present a sharply delineated edge which is recognisable even at its lower points, for instance to anyone driving east along the M4 from Bristol who sees the modest wall of the hills ahead five or six miles after leaving the city. Occasionally the escarpment gets above 1000 feet (Cleeve Hill just north of Cheltenham is such a point). Here it just manages nine hundred.

The escarpment begins at Bath in the south whence it runs roughly northwards to the vicinity of Wotton-under-Edge (the 'edge' being the scarp), then generally north-east for some forty miles (as crows fly) to end at Chipping Campden. You can follow the length of it on the 100-mile Cotswold Way, an imaginative piecing together of public footpaths and bridle-ways, initiated by the Ramblers' Association in the 1950s and first walked throughout in 1970. The Way does not stick rigidly to the scarp because it deviates to villages and woods and villas and earthworks. But

it keeps coming back to the top for the views, like the one from Leckhampton Hill and its battered chimney. Cheltenham is spread out immediately below. Beyond, the M5 (and not much else) separates Cheltenham from Gloucester. Then the Forest of Dean and the Black Mountains in Wales.

Walk up to the Chimney from Cheltenham, following the Cotswold Way round the scarp's contours on Charlton Kings Common. The ground has been much disturbed by past quarrying and the Chimney is said to be a remnant of this activity.

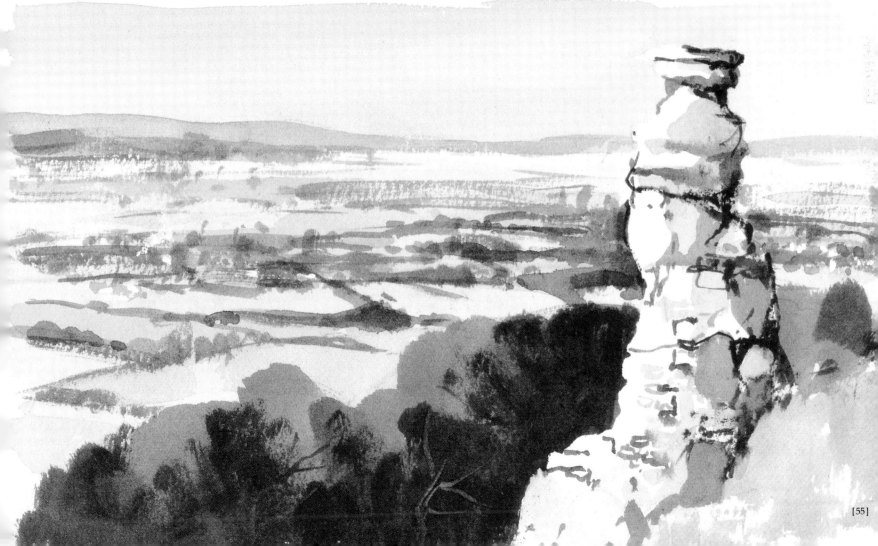

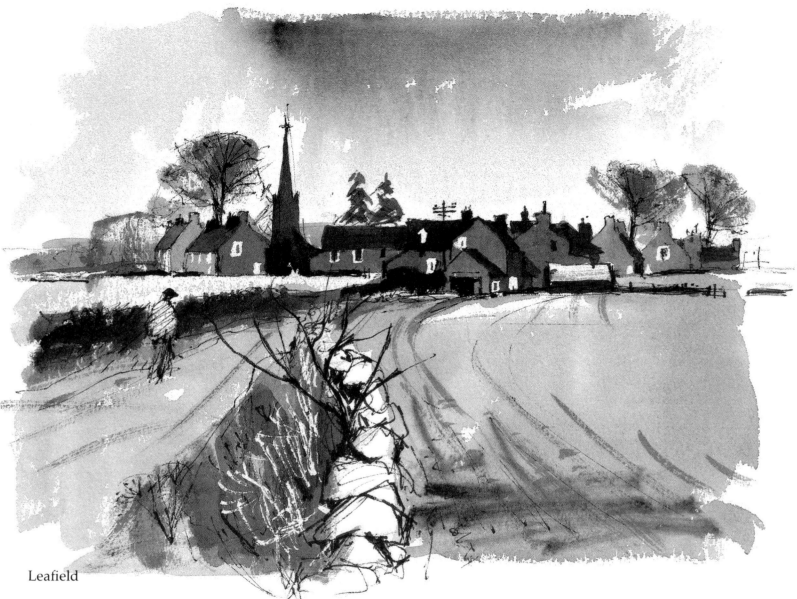

Leafield

We are almost out of the Cotswolds now. The spire of Leafield church, in this less hilly country, is a great landmark, visible from scores of places in the Thames valley and from the higher land to the north and west. It is a slightly bulbous spire and that betrays its Victorian origin. It was designed by Sir George Gilbert Scott whose best-known work is the Gothic fairy castle in front of St Pancras station. The church was completed in 1874 when the village was expanding. Until the disafforestation of the mid-1850s it had been entirely surrounded by Wychwood, the forest that stretched then from around Woodstock almost to Burford. When the trees came down and farming took over, places like Leafield grew accordingly.

Perhaps because of this relatively recent economic and physical upheaval, Leafield is anything but cosy in feel; and its windy ridge adds to the slight air of bleakness. Yet this is its fascination – and that of the surrounding countryside. Walk down the lane or footpaths to the next hamlet, Field Assarts. Like Leafield's, its name implies a clearing in the old forest. Or go on to the next hamlet, Fordwells, which simply did not exist before the great felling of Wychwood. Beyond lies Akeman Street, putting you in touch with a pattern of settlement that was old when Wychwood flourished. This was the Roman route striding north-eastwards from Cirencester.

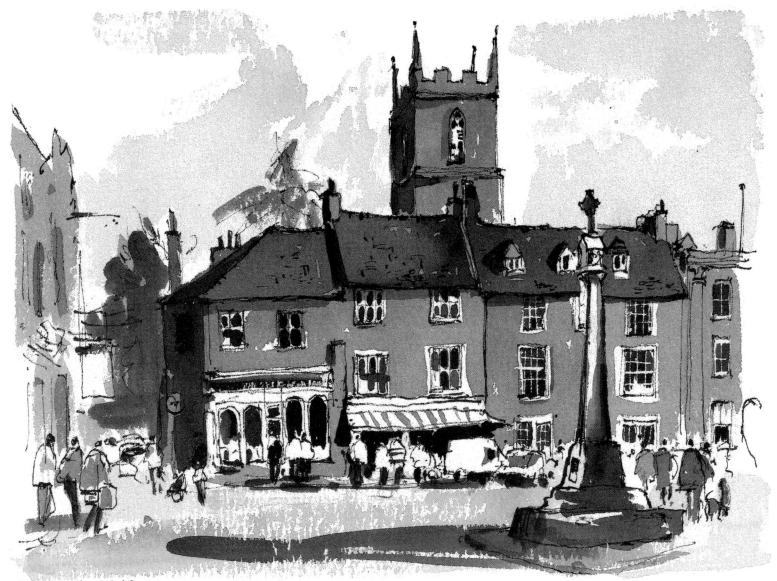

Stow-on-the-Wold

The lay-out of Stow has saved it from the excesses of Burford and Broadway. Nothing else does, for the buildings are quite as appealing and the site, right on the hill top, even more so. But the main road, the Foss Way in fact, slices along one side of the town and avoids the central square. Of course this does not mean that there are no useless boutiques, no pubs serving pretentious food, no art galleries. (If the number of art galleries in tourist towns is an indicator, what a cultural surge there has been in the last few decades.) But it does mean that you can get a flavour of what the place once was without too much hassle. Most telling are the handsome town houses. The church is not so grand as others in Cotswold towns, but its plain, floodlit tower is a superb landmark as you approach by night. It seems to have been the habit in the Civil War to keep prisoners in churches. They did at Burford, nine miles away and here too. The church was ruined, since when it has undergone two restorations.

Stow was a place where they used to sell sheep, but now the fair (three times a year) deals almost entirely in horses. This brings the gypsies, or travellers or tinkers, drifting down the roads, some in flash cars, some in battered trucks, a handful still in horse-drawn *vardos*. The residents roundabout love to point them out as a piece of mobile heritage, but how they hate them to stop anywhere near.

[57]

Macaroni Downs Farm

They do not (as far as I know) make pasta here. The name, which leaps oddly from the map, probably refers to the Macaroni Club, upper-crust London playboys of the late eighteenth century. They came racing in the district and the name – nobody knows why – was transferred to the sheep downs hereabouts. But there is nothing racy or louche about Macaroni Downs Farm today. It is an enchanted place approached by a valley which is more like a piece of the Yorkshire Dales than the Cotswolds. You can walk to it by paths from all sorts of directions, but the short way is from the road over the downs from Burford to Coln St Aldwyn, unclassified and windswept. But just where this road crosses the hardly detectable line of the Roman Akeman Street, it dips through a little wood to a stream. This is in fact the River Leach on its way from North*leach*, via the East*leaches*, to *Lech*lade. Leave the car here and turn right up the valley; where it forks bear right and keep on the farm track, carefully shutting the gates behind you, until you find the farm at the head of the valley. One of the beauties of this place is that the valley is all grass and sheep – not a scrap of cereal in sight.

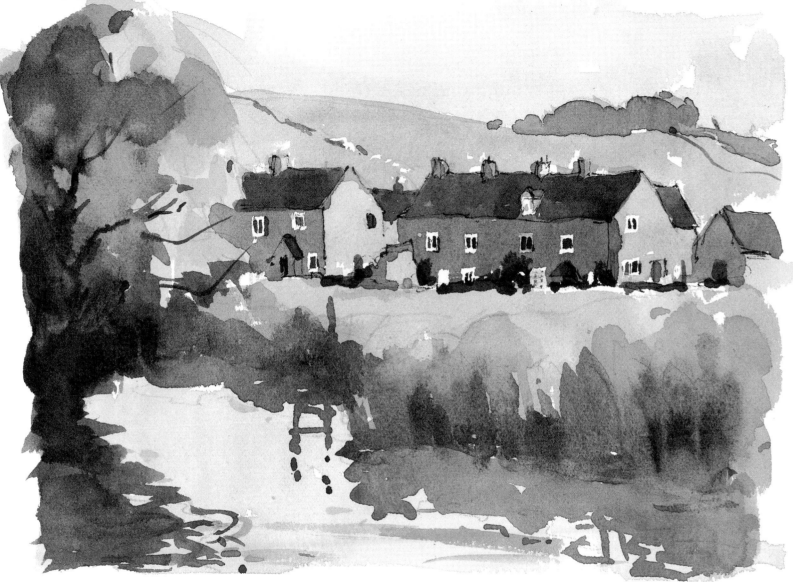

Upper Slaughter

Around here the village names come in pairs. There are the Upper and the Lower Swells, Bourton-on-the-Water and Bourton-on-the-Hill, Barringtons Great and Little; there are even trebles – Ascott-, Milton- and Shipton-under-Wychwood; Great, Little and Wyck Rissington. But the coupling we all remember is Upper and Lower Slaughter for their beauty and for their inevitability – if you travel by road you can hardly see one and avoid the other.

Of this famous pair, I slightly prefer the Upper. Its charms are somewhat less obvious and it holds one or two surprises. Look at those cottages on the square. They were 'remodelled' (delicate word for a delicate deed!) in Edwardian days by Sir Edward Lutyens – a far cry from Castle Drogo and the Cenotaph. There is a ford and what is more it is still in use. Of course there is a church which has been rather more than remodelled in its time. And there are two manor houses. A guidebook once referred to the Elizabethan one as 'perhaps the most beautiful domestic building in the Cotswolds', and a score of writers have repeated the claim since, so strapped are we for anything new to say about the much-guided Cotswolds. But you won't be able to check its claim to beauty for it is not open. On the other hand you will be able to see the village's fine dovecot from the outside – and who would want to inspect the interior?

Gloucester

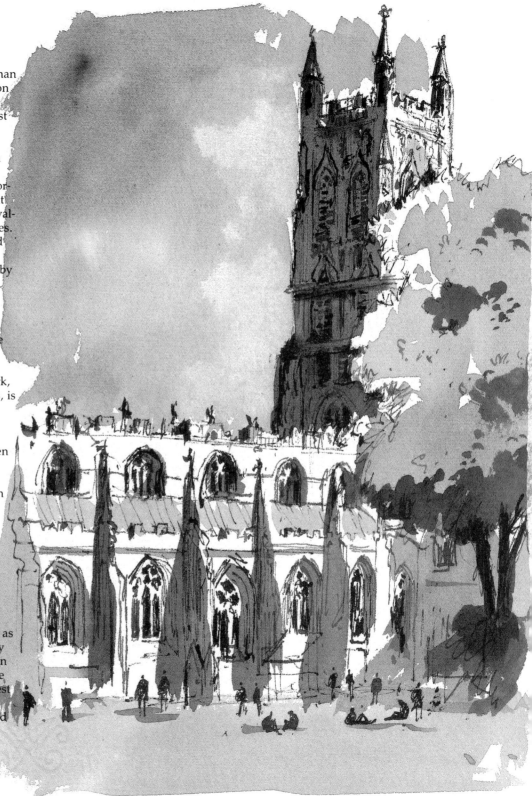

This is a city of the plain and the Severn rather than of the hills although the Cotswolds crowd in upon its eastern flank almost as close as they do upon Cheltenham's. Gloucester has always looked west rather than east. The Romans built Glevum (roughly the area now demarcated by the streets Northgate, Eastgate, Southgate and Westgate) in the first century AD to facilitate an invasion of Wales. Later the city stood strategically on the borders of Mercia and Wessex and in the Civil War it was a Parliamentary stronghold between the Royalist capital at Oxford and the King's forces in Wales. It was an important port until Bristol, better-sited downstream, overhauled it, but it still has docks and handsome warehouses joined to the Severn by a canal dating from 1827.

The city has the usual bricky skirt of housing and industrial estates and a ring-road to take you around them. But as you descend into the sprawl from the escarpment of the Cotswolds the massively lovely fifteenth-century tower of the cathedral rises in the middle like a lily.

The Normans built the cathedral and their work, put together over the better part of two centuries, is still the gripping heart of the whole. The great columns of the nave are as powerful as Romanesque work anywhere in Europe. I remember a carol service here on a mid-winter afternoon when candles threw weirdly leaping shadows on those enormous cylinders, recreating the mixture of terror and homely comfort which must have been a driving force of medieval Christianity. And those cylinders have something worthy of their grace and strength to uphold – a Norman arcade and above that an Early English wall pierced by windows.

But the Norman is far from all. The great east window in the choir is the largest stained-glass window anywhere in Britain and it is a war memorial to those who died at Crecy in 1346. It measures a grandiloquent 78 feet by 38 feet. And as you approach the cathedral from outside it is easy to think this is a Perpendicular building. The main reason for this is the dominating tower itself. Like most of the cathedral it is made of one of the palest Cotswold stones – that from Painswick – and is embellished by elegant blank arcading and topped off with battlements and pinnacles of open work through which we see the sky.